THE ART AND HISTORY OF BOOK PRINTING

A Topical Bibliography

Dedicated to My Nieces and Nephews
With Gratitude and Affection

THE ART AND HISTORY OF BOOK PRINTING

A Topical Bibliography

Compiled by *Vito J. Brenni*

GREENWOOD PRESS
Westport, Connecticut • London, England

Library of Congress Cataloging in Publication Data

Brenni, Vito Joseph, 1923-
 The art and history of book printing.

 Includes indexes.
 1. Printing—Bibliography. 2. Book industries and
trade—Bibliography. I. Title.
Z117.B82 1984 016.6862 83-20696
ISBN 0-313-24306-9 (lib. bd.)

Library of Congress Catalog Card Number: 83-20696
ISBN: 0-313-24306-9

First published in 1984

Greenwood Press
A division of Congressional Information Service, Inc.
88 Post Road West, Westport, Connecticut 06881

Printed in the United States of America

10 9 8 7 6 5 4 3 2 1

CONTENTS

PREFACE

The Gutenberg invention of the printing press in the fifteenth century marked the beginning of a new era in the history of mankind. For the first time books could be made available in multiple copies for a larger population of readers. Knowledge, inspiration, and all that books contain could be within the reach of every person who knew how to read. The benefits to society and civilization would be phenomenal, as indeed they have been. This volume, a bibliographic guide to the literature on the art and history of book printing, is a celebration of both the invention of printing and the printed book.

Included among the 1,060 citations in the bibliography are general reference works and publications on such topics as the history and techniques of methods of printing; printing machinery and materials; the history of book printing; the printing of maps, of mathematics, and of medical, musical, religious, and scientific data; Hebrew printing; the private press; printers' marks; and forgery and fictitious imprints. In general, the titles represent a selection of the more important and useful writings on the subject. Types of work extend to books, theses, parts of books, periodical articles, and library, exhibit, and sales catalogs. The publications are in English, French, German, Italian, Spanish, and many other languages. Some entries have annotations containing information on editions, special features, and additional sources of information.

Writings about the printing of individual books are omitted except for those on the Bible and the Haggadah. The subjects of children's books, the printing of illustrations, and printing on bindings are also excluded. For the last two areas, the reader is referred to the compiler's *Book Illustration and Decoration: A Guide to Research* (Greenwood Press, 1980) and *Bookbinding: A Guide to the Literature* (Greenwood Press, 1982).

Although numerous entries listed in this work make a substantial and notable contribution to the story of printing in many parts of the world, particularly several noted among the reference works and in the section on the history of printing, details on printing in individual countries must be reserved for supplementary volumes. Citations specific to book printing in the United States and the United Kingdom are available in the compiler's *Book Printing in Britain and America: A Guide to the Literature and a Directory of Printers* (Greenwood Press, 1983). In the present work separate headings for

individual countries can be found in the sections on maps, music, medicine, religion, and science. The titles listed under these headings are about the history of the printed book in those subject areas for the particular countries. The sections on Hebrew printing and printers' marks also contain entries for individual countries.

The section on the history and technique of the methods of printing does not have a separate heading for letterpress printing, which, for many years was the chief method. To avoid duplication and save space, printers' manuals for this method are listed under the countries in which they were published. Many old manuals published before the twentieth century are included. Some books on the printing of illustrations can be found in this section, but a much longer list of pertinent titles is included in the author's bibliography *Book Illustration and Decoration* cited above.

For the history of book printing, titles were selected with the needs of both the student and the scholar in mind. Brief readable histories, short essays in standard works, and articles in well-known works are intended for the student and general reader. Scholarly monographs and articles in professional and learned journals are for the scholar, specialist, and student pursuing a topic at considerable length.

Some of the entries on map printing have little or nothing specifically on the subject; that is, they do not contain essays about map printing. They were chosen because they contain maps that the reader can examine for particular information he or she may need relating to the lettering, typography, and printing processes of maps. Several excellent general compilations of maps in one or more volumes are among the notable titles. For additional maps, the reader will want to consult the titles under the names of individual countries. In searching for these titles an effort was made to find the most useful works, as well as the monumental collections and the scholarly treatises.

The printing of religious works and printing for the church are two large areas in need of much more historical scholarship and bibliographic research. Catalogs and bibliographies without facsimiles were not included in this section nor in the other parts of this work, except for those specifically about printing. Some exceptions were made for special reasons. For more catalogs and bibliographies, the student should refer to the very valuable *World Bibliography of Bibliographies* by Theodore Besterman (4th ed., Lausanne, Societas Bibliographica, 1965-1966).

Writings about individual private presses and printers have been reserved for a supplementary volume of this bibliography. They will appear under the names of countries and will be interfiled with the entries on other printing firms and publishers.

The two classified checklists that appear at the end of the present volume, on writing and calligraphy and on typography respectively, are included because the subjects relate to book printing. Typography is based on those written forms that existed before and after the invention of printing. For

designing type, early printers used manuscripts in order to copy and modify the letters used in words written by scribes. Calligraphers and calligraphic manuals were also influential in the making of type. The titles in the checklists represent a selection of some of the more important works in English and other languages on writing, calligraphy, and typography. For more English-language publications on calligaphy, consult *Calligraphy: A Sourcebook* by Jinnie Y. Davis and John V. Richardson (Libraries Unlimited, 1982).

The author index includes authors, editors, revisers, writers of introductions, and annotators. The subject index is complete for informaiton in the titles and the annotations. Cross-references are provided to facilitate the use of the indexes.

Though I have had access to many libraries for most of my life, I have not ceased to be grateful for the privilege of having used them for study, reading, and browsing. I still consider the use of a library a privilege and not a fundamental or human right. When I remember how much time and effort have gone into the making and organization of the collections, I am even more sure that I am correct in my choosing the word "privilege" with the meaning that is given in Webster's *Third New International Dictionary*: "a right or immunity granted as a peculiar benefit, advantage, or favor." The dictionary goes on to say that it is "a special enjoyment of a good." Because over the years my experience with libraries has included much bibliographic research, I am inclined to believe that I have, indeed, enjoyed a special privilege by virtue of the heavy use I have made of them, in particular the two largest university libraries in southern Michigan, those at the University of Michigan and Michigan State University. Without them this bibliographer would not have been able to see most of the titles listed in this work. To these libraries and their staffs I owe a special debt of gratitude and appreciation.

THE ART AND HISTORY OF BOOK PRINTING

A Topical Bibliography

REFERENCE WORKS

Bibliographies

1. Annual bibliography of the history of the printed book and libraries. Vol. 1, 1970- The Hague, Martinus Nijhoff, 1973-

> Edited by Hendrik D. L. Vervliet under the auspices of the International Federation of Library Association's Committee on Rare and Precious Books and Documents.

2. Appleton, Tony. A typological tally; thirteen hundred writings in English on printing history, typography, bookbinding, and papermaking. Brighton, Dolphin Press, 1973. 94p.

3. Besterman, Theodore. Printing, book collecting and illustrated books; a bibliography of bibliographies. Totowa, N.J., Rowman and Littlefield, 1971. 2 vols.

4. Bibliographie des Bibliotheks- und Buchwesens. Leipzig, 1904-12; 1922-25.

> Superseded by Internationale Bibliographie des Buch- und Bibliothekswesen. Leipzig, 1926-40.

5. Bigmore, Edward C. and Wyman, Charles W. A bibliography of printing with notes and illustrations. London, Quaritch, 1880-1886. 3 vols.

> The 2d ed. published in New York in 1945 is a reprint.

6. Bohatta, Hanns and Hodes, Franz. Internationale Bibliographie der Bibliographien. Frankfurt, Klostermann, 1950. 652p.

> See "Inkunabeln," p.58-72 and "Buchdruck," p.26-45.

7. Börsenverein der Deutschen Buchhandler. Bibliothek. Katalog der Bibliothek ... Leipzig, 1885-1902. 2 vols.

8. British Federation of Master Printers. 100 technical books; a suggested nucleus for a printing works library. Prepared by Albert Kirk. London, 1956. 15p.

9. _____. A selected list of graphic arts literature books and periodicals. London, 1948. 72p.

10. Clair, Colin. "Bibliography." (In A history of European printing. London, Academic Press, 1976. p.447-64)

11. Claudin, Anatole. Les traveaux sur l'histoire de l'imprimerie.
Paris, 1899. 22p.

12. Columbia University Libraries. The history of printing from its
beginning to 1930; the subject catalog of the American Type Founders
Company Library in the Columbia University Libraries. Millwood, N.Y.,
Kraus, 1980. 4 vols.

13. Cuitino, Carlos C. "Printing industry sources of information."
Special libraries 60:651-56, Dec. 1969.

14. Edward Clark Library. Catalogue of the Edward Clark Library with
typographical notes by Harry Carter.... Ed. by P. J. W. Kilpatrick.
Privately printed for Napier College of Commerce and Technology, Lothian
Regional Council, 1976. 2 vols. many plates and facs

> The Collection is in Napier College, Edinburgh. An excellent
> catalog with essays on printing for each century and many facsimiles
> of text and title pages. See long review by G. D. Hargreaves in
> Bibliotheck 9, no.1:21-24. 1978.

15. Freer, Percy. Bibliography and modern book production; notes and
sources for student, librarians, printers, booksellers, stationers, book
collectors. Johannesburg, Witwatersrand Univ. Press, 1954. 345p.

16. Gerber, Jack. A selected bibliography of the graphic arts.
Pittsburgh, Graphic Arts Technical Foundation, 1967. 84p.

17. Howe, Ellic. "Bibliotheca typographica." Signature no.10:49-64.
1950.

> An excellent bibliographical essay with critical comments on many
> titles.

18. International bibliography of historical sciences, ed. for the
International Committee of Historical Sciences.... 1926- Imprint varies.
Now published by Saur in Munich. Annual.

> See Section A: "Auxiliary sciences: history of the book."

19. Koda, Paul S. "The language of the book." AB bookman's weekly,
Sept. 8, 1980, p.1315, 1318-36.

> An annotated list of dictionaries and glossaries of the book arts.

20. Lehmann-Haupt, Hellmut. Seventy books about bookmaking. N.Y.,
Columbia Univ. Press, 1941. 67p.

21. Lexikon des Buchwesens. Hrsg. von Joachim Kirchner. Stuttgart,
Hiersemann, 1952-56. 4 vols. illus.

> Many articles contain bibliographies.

22. Manchester Public Libraries. Reference Library. Subject catalogue,
section 655: printing. Manchester, 1961-63. 2 vols.

23. Milkau, Fritz. Handbuch der Bibliothekswissenschaft. 2d ed. Ed.
by Georg Leyh. Wiesbaden, Harrassowitz, 1952. 2 vols.

See chapters 5 and 6 on printing in vol. 1. Many titles in
footnotes.

24. Mills, George J. Guide to films, periodicals, and books in printing,
paper, publishing, printed advertising, and their closely related
industries. Pittsburgh, School of Printing Management, Carnegie Insti-
tute of Technology, 1956. 64p.

25. National Book League, London. Library. Books about books;
catalogue of the Library of the National Book League. London, Cambridge
Univ. Press for the National Book League, 1955. 126p.

26. Newberry Library. Dictionary catalogue of the history of printing
from the John M. Wing Foundation in the Newberry Library. Boston,
G. K. Hall, 1962. 6 vols. First supplement, 1970. 3 vols. Second
supplement, 1981. 4 vols.

27. Northup, Clark S. "Printing and publishing." (In A register of
bibliographies of the English language and literature. New Haven, Yale
Univ. Press, 1925. p.301-21)

The bibliographies are chiefly for Great Britain and the United
States.

28. Printing and the mind of man; a descriptive catalogue illustrating
the impact of print on the evolution of western civilization during five
centuries. Compiled and edited by John Carter and Percy H. Muir.
Assisted by Nicolas Barker, H. A. Feisenberger, Howard Nixon, and S. H.
Steinberg. With an introductory essay by Denys Hay. London, Cassell,
1967. 280p.

29. Reed, Talbot B. "List of books and papers on printers and printing
under the countries and towns to which they refer." Ed. by A. W. Pollard.
Transactions of the Bibliographical Society 3, pt.1, p.85-152. 1895.

30. St. Bride Foundation. Catalogue of the Technical Reference Library
of works on printing and the allied arts. London, Printed for the
Governors, 1919. 999p.

An author list with no subject index.

31. _____. Catalogue of the periodicals relating to printing and
allied subjects in the technical library of St. Bride Institute.
London, 1950. 35p.

32. Tanselle, G. Thomas. "The periodical literature of English and
American bibliography." Studies in bibliography 26:167-91. 1973.

33. Typothetae of the City of New York. Library. Catalogue of the
books in the Library ... with a subject index. N.Y., De Vinne Press,
1896. 176p.

An author list with some notes. Subject index, p.155-76.

34. Ulrich, Carolyn and Kup, Karl. Books and printing: a selected list of periodicals 1800-1942. N.Y., New York Public Library, 1943. 244p.

35. U.N. Industrial Development Organization, Vienna. Information sources on the printing and graphics industry. N.Y., 1975. 65p. (Unido guides to information sources 14)

36. U. S. Congress. Joint Committee on Printing. Bibliography on electronic composition. Wash., Gov't Printing Office, 1970. 58p.

37. Virginia. University.Bibliographical Society. Studies in bibliography; papers. Charlottesville, 1948/49 to date. Annual.

See "Selective checklist of bibliographical scholarship" in each vol. beginning with vol. 3(1950) and ending with vol. 27(1974).

38. Winckler, Paul A. History of books and printing; a guide to information sources. Detroit, Gale Research, 1979. 209p.

An annotated bibliography on the alphabet and writing, typography, book illustration, bookbinding, nonprint media,and periodicals and annuals. Also contains a list of libraries, special collections and museums, associations, societies and clubs, and book dealers. The section on the history of books and printing has 183 entries.

Biographical Reference Works

39. Ceux qui font; dictionnaire biographique de l'édition et des arts graphiques. Paris, Editions France Expansion, 1977. 267p.

40. Heichen, Paul H. Taschen-Lexikon der hervorragenden Buchdrucker und Buchhändler seit Gutenberg bis auf Gegenwart. Leipzig, Schafer, 1884. 343p.

41. Lenhart, John M. Introduction to checklists of names of places where typography was applied, of master printers, printers, workmen, publishers, etc. St. Louis, Central Bureau, Catholic Central Union, 1959. 130p.

42. Presser, Helmut. ABC der grossen drucker. Mainz, Eggebrecht-Presse, 1951. 58p.

43. Timperly, Charles H. A dictionary of printers and printing. London, Johnson, 1839. 996p.

Reissued in 1842 with title Encyclopedia of literary and typographical anecdotes.

44. Who's who in graphic art; an illustrated book of reference to the world's leading graphic designers, illustrators, typographers, and cartoonists. Zurich, Amstutz & Herdeg Graphis Press, 1962. 586p. LXVIIIp.

Dictionaries

45. Allen, Edward M. Harper's dictionary of the graphic arts. N.Y.,
Harper, 1963. 295p.

46. Arneudo, Giuseppe. Dizionario esegetico, tecnico, e storico per le
arti grafiche. Torino, 1913-25. 3 vols.

47. Björklund, Georg. Litet boklexikon for skolor och bibliotek.
Stockholm, Almqvist & Wiksell, 1963. 71p. illus. facs

48. The bookman's concise dictionary. N. Y., Philosophical Library,
1956. 318p.

49. Boutmy, Eugène. Dictionnaire de l'argot des typographes....
Paris, Marpon et Flammarion, 1883. 140p.

50. Brownstone, David M. and Franck, Irene M. Dictionary of publishing.
N.Y., Van Nostrand Reinhold, 1982. 302p.

 Contains many terms on printing.

51. Buonocore, Domingo. Diccionario de bibliotecologia. Sante Fe,
Argentina, Castellvi, 1963. 336p.

52. Carter, John. ABC for book collectors. 6th ed. With corrections
and additions by Nicolas Barker. London, Granada, 1980. 219p.

53. Chautard, Emile. Glossaire typographique. Paris, Editions Denoël,
1937. 155p.

54. Collins, F. Howard. Authors' and printers' dictionary. 11th ed.
Rev. by Stanley Beale. London, G. Cumberlege, Oxford Univ. Press, 1973.
474p.

55. Composition Information Services. Glossary of automated typesetting
and related computer terms. 2d ed. Los Angeles, 1966. 105p.

56. Comte, René and Pernin, André. Lexique des industries graphiques.
Paris, Compagnie Française d'Editions, 1974. 127p.

57. Durbin, Harold C. Terminology, printing and computer. Easton, Pa.,
Durbin Associates, 1980. 206p.

58. Emori, Kenji. Hon no shojiten. 1955. 401p. illus.

59. Fumagalli, Giuseppe and Bernard, Giovanni. Vocabolario biblio-
grafico. Florence, Olschki, 1940. 450p.

60. Garland, Ken. Illustrated graphics glossary.... London, Barrie
and Jenkins, 1980. 192p.

61. Glaister, Geoffrey A. Glaister's glossary of the book. 2d ed.,
completely revised. Berkeley, Univ. of California Press, 1979. 551p.
illus. plates.

62. Harrod, Leonard M. The librarian's glossary. 4th rev. ed. London, Deutsch, 1977. 903p.

63. Hiller, Helmut, ed. Worterbuch des Buches. 3d ed. Frankfurt, Klostermann, 1967. 341p. 4th ed., 1980.

64. Hostettler, Rudolf. Technical terms of the printing industry. 5th ed. St. Gallen, Zollikofer, 1969. 195p. (polyglot)

65. Jacobi, Charles T. The printers' vocabulary.... London, Chiswick Press, 1888. 168p.

66. Joseph i Mayol, Miquel. Com es fa un libre: diccionari de las arts grafiques. Barcelona, Editorial Portic, 1979. 326p. illus.

67. Kenneison, W. C. and Spilman, A. J. B. Dictionary of printing, papermaking and bookbinding. London, George Newnes, 1963. 215p.

68. Koch, Herbert. Der Wortschatz der spanischen Buchdrucker. Mainz, Gutenberg-Gesellschaft, 1970. 32p.

69. Lexograph: Internationale Handbuch für die graphischen und papierverarbeitende Industrie. 2d ed. Stuttgart, Belsen Verlag, 1968. 602p. (polyglot)

70. Mintz, Patricia B. Dictionary of graphic arts terms. N.Y., Van Nostrand Reinhold, 1981. 318p. illus.

71. Muller, Wolfgang, ed. Dictionary of the graphic arts industry: in eight languages: English, German, French, Russian, Spanish, Polish, Hungarian, Slovak. Amsterdam, Elsevier Scientific Pub. Co., 1981.

72. Neuburger, Hermann. Encyklopädie der Buchdruckerkunst. Leipzig, R. Friese, 1844. 262p.

73. Orne, Jerrold. The language of the foreign book trade: abbreviations, terms, phrases. Chicago, American Library Association, 1962. 3d ed., 1976. 333p.

74. Peignot, Etienne G. Dictionnaire raisonné de bibliologie. Paris, Renouard, 1802. 2 vols. Supplement, 1804.

75. Peters, Jean, ed. The bookman's glossary. 5th ed. N. Y., Bowker, 1975. 169p.

76. Pipics, Zoltán, ed. The librarian's practical dictionary in 22 languages. 6th rev. and enl. ed. Pullach/Munich, Verlag Dokumentation, 1974. 385p.

77. Robinson, L. J. A dictionary of graphical symbols. London, F. C. Avis, 1972. 360p.

78. Rodriguez, Cesar and Humphrey, George A., eds. Bilingual dictionary of the graphic arts (English-Spanish, Spanish-English). Farmingdale, N.Y., George A. Humphrey, 1966. 448p.

79. Rust, Werner. Lateinisch-griechische Fachworter des Buch- und Schriftwesens. Leipzig, Harrassowitz, 1950. 68p.

80. Schlemminger, Johann. Factworterbuch des Buchwesens. Deutsch, Englisch, Französisch. 2d ed. Darmstadt, Stoytscheff, 1954. 367p.

81. Thompson, Anthony. Vocabularium bibliothecarii. English, French, German, Spanish, Russian, Slovak. 2d ed. Paris, Unesco, 1969. 686p.

82. Uemura, Chozaburo. Shoshigaku jiten. Kyoto, 1942. 22, 514, 66p.

83. Vitale, Philip H. Bibliography, historical and bibliothecal; a handbook of terms. Chicago, Loyola Univ. Press, 1971. 251p.

84. Wallis, L. W. Printing trade abbreviations. London, Avis, 1960. 126p.

85. Walter, Frank K. Abbreviations and technical terms used in book catalogs and in bibliographies. Boston, Boston Book Co., 1912. 167p.

86. Wijnejus, F. J. M. Elsevier's dictionary of the printing and allied industries in four languages, English, French, German, Dutch. Amsterdam, Elsevier, 1967. 583p.

87. Yagi, Sakichi. Shomotsugo jiten. Tokyo, 1976. 220p.

Encyclopedias

88. American dictionary of printing and bookmaking, containing a history of these arts in Europe and America, with definitions of technical terms and biographical sketches. Ed. by W. W. Pasko. New introduction by Robert E. Runser. Detroit, Gale Research, 1967. 592p. illus. facs

First issued in parts in The American bookmaker, Apr. 1891-Mar. 1894. Published in one volume in 1894 by Lockwood. Contains many illustrations and portraits.

89. La chose imprimée. Sous la direction de John Dreyfus and François Richaudeau. Paris, Retz-C.E.P.L., 1977. 640p. illus.

90. Encyclopedia of library and information science. Ed. by Allen Kent et al. N.Y., Dekker, 1968-1982. 33 vols.

91. Encyklopedia wiedzy o ksiazce. Komitet redakcyjny: Alexander Birkenmayer et al. Wroclaw, Zaklad Narodowy im. Ossolinskich, 1971. 2874 columns. illus.

92. Glaister, Geoffrey A. Glaister's glossary of the book. 2d ed., completely revised. Berkeley, Univ. of California Press, 1979. 551p. illus. plates.

93. Graphic arts manual. N.Y., Arno Press, Musarts Publishing Corp., 1980. 650p.

94. Lexikon des Buchwesens. Hrsg. von J. Kirchner. Stuttgart,
Hiersemann, 1952-56. 4 vols. (The Bilderatlas constitutes vols. 3 and
4)

95. Nordisk leksikon for bogvaesen. Redg. af E. Dansten et al.
Copenhagen, 1949-62. 2 vols.

96. Ringwalt, J. Luther, ed. American encyclopedia of printing.
Phila., Menamin & Ringwalt, 1871. 512p. illus.

97. Savage, William. A dictionary of the art of printing. London,
Longman, Brown, Green, and Longmans, 1841. 815p. illus.

98. Stevenson, George A. Graphic arts encyclopedia. N.Y., McGraw-Hill,
1968, 492p. illus. 2d ed., 1978.

99. Timperley, Charles H. A dictionary of printers and printing, with
the progress of literature, ancient and modern.... London, H. Johnson,
1839. 996p. illus.

 A mine of information on everything pertaining to printing. Con-
 tains a separate index of names of persons, p.967-83, and a general
 index, p.985-96.

100. Waldow, Alexander. Illustrierte Encyklopädie der graphischen Kunst
und der verwandten Zweige. Leipzig, The Author, 1884. 911p. illus.

 Gazetteers

101. Burger, Konrad. Ludwig Hain's Repertorium bibliographicum.
Register: Die Drucker des xv. Jahrhunderts. Leipzig, Harrassowitz, 1891.
428p.

102. Cotton, Henry. A typographical gazetteer. Oxford, Clarendon Press,
1825. 219p. 2d ed., 1831. 2d series, 1866.

103. Deschamps, Pierre C. Dictionnaire de géographie ancienne et moderne
à l'usage du libraire et de l'amateur de livres ... par un bibliophile.
Paris, Firmin Didot frères, fils, 1870. 1594 columns.

 Additions and corrections by Carlos Sommervogel in Revue des
 bibliothèques, 1894, p.91-106.

104. _____. L'imprimerie hors de l'Europe. Paris, Maisonneuve, 1902.
203p.

105. Reichhart, Gottfried. Beiträge zur Inkunabelnkunde. Leipzig,
Harrassowitz, 1895. 464p.

Handbooks of Chronology

106. Berry, W. Turner and Poole, H. Edmund. Annals of printing; a
chronological encyclopedia from the earliest times to the present.
London, Blandford, 1966. 315p.

107. Billoux, René. Encyclopédie chronologique des arts graphiques.
Paris, 1943. 305p.

108. Clair, Colin. A chronology of printing. London, Cassell, 1969.
228p.

109. Gentry, Helen and Greenwood, David. Chronology of books and
printing. N.Y., Macmillan, 1936. 186p.

110. Lawson, Alexander S. A printer's almanac. Phila., North American
Publishing Co., 1966. 257p. (vol. 2 of The heritage of the printer)

111. Muller, Julius W. "A chronology of printing giving the principal
dates and personages in printing history." (In Bartlett, Edward E.
The typographic treasures in Europe.... N.Y., Putnam, 1925. p.59-185)

112. Timperley, Charles H. A dictionary of printers and printing.
London, H. Johnson, 1839. 996p. illus.

113. Warde, Beatrice L. Thirty-two outstanding dates in the history of
printing. Guildford, Guildford School of Art, 1949. 14p.

HISTORY AND TECHNIQUE
OF METHODS OF PRINTING

(For letterpress printing see printers' manuals of individual
countries following Reprography below)

Reference Works

114. Barber, Giles. French letterpress printing; a list of French
printing manuals and other texts in French bearing on the technique of
letterpress printing 1567-1900. Oxford, Oxford Bibliographical Society,
1969. 30p.

115. Gaskell, Philip et al. "An annotated list of printers' manuals to
1850." Journal of the Printing Historical Society no. 4:11-32. 1968.

 A list of English, French, and German manuals, and one in
 Spanish. Library locations are given.

116. Wroth, Lawrence C. "Corpus typographicum; a review of English and
American printer's manuals." (In Typographic heritage. N.Y., The
Typofiles, 1949. p.55-90)

Layout

117. Hurlburt, Allen. Layout: the design of the printed page. N.Y.,
Watson-Guptill, 1977. 159p. illus.

118. Nelson, Roy P. Publication design. 2d ed. Dubuque, Iowa, W. C.
Brown, 1978. 295p. illus.

119. Silver, Gerald A. Graphic layout and design. N.Y., Van Nostrand
Reinhold, 1981. 312p. illus.

120. White, Jan V. Graphic idea notebook; inventive techniques for
designing printed pages. N.Y., Watson-Guptill, 1980. 192p.

120a. Barnett, Michael P. Computer typesetting; experiments and pros-
pects. Cambridge, MIT Press, 1965. 245p. illus.

Composition and Press Work

121. De Vinne, Theodore. The practice of typography: correct composition.... N.Y., Century, 1901. 476p.

122. _____. The practice of typography: modern methods of book composition. N.Y., Century, 1904. 477p.

123. Gress, Edmund G. The American manual of press work. N.Y., Oswald, 1911. 155p. 2d ed., 1916. 165p.

124. Mansfield, Arthur J. Composition and presswork. Melrose, Mass., The Author, 1932. 223p.

125. Rice, Stanley. CRT typesetting handbook. N.Y., Van Nostrand Reinhold, 1981. 409p. illus.

126. _____. Type-caster; universal copyfitting. N.Y., Van Nostrand Reinhold, 1980. 90p.

127. Stewart, Alexander A. Typesetting.... Chicago, United Typothetae of America, 1919. 94p. illus.

128. Stower, Caleb. Compositor's and pressman's guide to the art of printing. London, B. Crosby, 1808. 140p.

129. U. S. Government Printing Office. Theory and practice of presswork. Wash., D.C., 1948. 248p.

130. Van Uchelen, Rod. Word processing; a guide to typography, taste, and in-house graphics. N.Y., Van Nostrand Reinhold, 1980. 128p. illus.

130a. Williams, James G. "Computer-aided composition." Encyclopedia of library and information science 24:107-16. 1978.

131. Wooldridge, Dennis. Letter assembly in printing. N.Y., Hastings House, 1972. 301p. illus.

Proofreading and Copy Editing

132. Brossard, Louis E. Le correcteur typographe; essai historique, documentaire et technique. Tours, E. Arrault, 1924. 587p.

133. Butcher, Judith. Copy-editing; the Cambridge handbook. 2d ed. Cambridge, Univ. Press, 1981. 331p.

134. Bylinskii, Konstantin. Spravnochnaia kniga korrektore. Moscow, 1960. 544p.

135. Camp, Sue C. Developing proofreading skill. N.Y., McGraw-Hill, 1980. 112p.

136. Hornschuch, Hieronymus. Instructio operas typographicas correctures.
Leipzig, Lantzenberger, 1608. 16, 45p. illus.

Edited and translated into English by Philip Gaskell and Patricia
Bradford in 1972.

137. Lasky, Joseph. Proofreading and copy preparation; a textbook for
the graphic arts industry. N.Y., Mentor Press, 1941. 656p. 3d ed.,
1949.

138. McNaughton, Harry H. Proofreading and copyediting; a practical
guide to style for the 1970s. N.Y., Hastings House, 1973. 176p.

139. Tassis, S. A. Guide du correcteur et du compositeur. 6th ed.
Paris, F. Didot frères, 1862. 106p.

Lithography

140. Antreasian, Garo Z. and Adams, Clinton. The tamarind book of
lithography; art and techniques. N.Y., Abrams, 1971. 464p.

Contains an annotated bibliography, p.449-53.

141. Bild vom Stein; die Entwicklung der Lithographie von Senefelder
bis heute. Munich, Prestel-Verlag, 1961. illus.

A valuable catalog with extensive and scholarly notes.

142. Cumming, David. Handbook of lithography; a practical treatise for
all who are interested in the process. London, A. and C. Black, 1904.
248p.

143. Engelmann, Godefroi. Traité de lithographie. Mulhouse, 1839.
467p.

144. Faux, Ian. Modern lithography. 2d ed. Plymouth, MacDonald and
Evans, 1978. 334p.

145. Griffits, Thomas E. The rudiments of lithography. London, Faber
and Faber, 1956. 95p.

146. Hartrick, Archibald S. Lithography as a fine art. London, Oxford
Univ. Press, 1932. 83p.

147. Krueger, Otto F. Die lithographischen Verfahren und der Offsetdruck.
3d ed. Leipzig, 1949. 278p.

148. Lawson, L. E. Offset lithography. London, Vista Books, 1963.
184p. illus.

149. Marthold, Jules de. Histoire de la lithographie. Paris, L. H. May,
1898. 64p.

150. Nicholson, Donald. Photo-offset lithography. N.Y., Chemical
Publishing Company, 1941. 154p.

151. Peignot, Gabriel. Essai historique sur la lithographie. Paris, Renouart, 1819. 61p.

152. Senefelder, Alois. Vollstandiges Lehrbuch ... der Steindruckerey ... Verfasst und herausgegeben von dem Erfinder der Lithographie. München, C. Thienemann, 1818. 120p.

Translated into English in 1911 by J. W. Muller and published by Fuchs and Lang.

153. Strauss, Victor, ed. The lithographers manual. 20th anniversary edition. N.Y., Waltwin, 1958. 2 vols.

154. Vicary, Richard. Manual of lithography. N.Y., Scribner, 1976. 152p.

155. Vidal, Léon. Traité pratique de photolithographie. Paris, 1893. 419p.

156. Weber, Wilhelm. History of lithography. Tr. from the German. London, Thames and Hudson, 1966. 259p.

German title: Saxa loquuntur--Steine reden: Geschichte der Lithographie, I: von den Anfängen bis 1900. Heidelberg, 1961.

157. Willy, Clifford M. Practical photolithography. 4th ed. Ed. and rev. by G. E. Messinger. London, Pitman, 1952. 240p.

Stereotyping and Electrotyping

158. Goggin, Joseph D. Manual of stereotyping. Chicago, 1935. 256p.

159. Hodgson, Thomas. Essay on the origin and progress of stereotype printing, including a description of the various processes. Newcastle, S. Hodgson, 1820. 178p. plates.

160. Kubler, George A. Historical treatises, abstracts, and papers on stereotyping. N.Y., Little and Ives, 1936. 169p.

161. _____. A new history of stereotyping. N.Y., Printed by J. J. Little and Ives, 1941. 362p.

162. _____. A short history of stereotyping. Brooklyn, Brooklyn Eagle Commercial Printing Dept., 1927. 93p.

163. Partridge, Charles S. Reference book of electrotyping and stereotyping. Giving information and instruction regarding processes, materials and machinery. Chicago, Inland Printer, 1905. 134p.

164. _____. Stereotyping: practical treatise of all known methods of stereotyping. Chicago, Inland Printer, 1909. 172p.

165. Wilson, Frederick J. Stereotyping and electrotyping. London, Wyman, 1880. 195p.

Photomechanical Processes

166. Ammonds, Charles C. Photoengraving; principles and practice. London, Pitman, 1966.

167. Burton, William K. Practical guide to photographic and photo-mechanical printing. London, Marion, 1887. 355p. rev. in 1898, 1907, and 1928.

168. Cartwright, Herbert M. Photogravure; a textbook on the machine and hand printed processes. Boston, American Photographic Publishing Co., 1930. 142p.

169. Cogoli, John E. Photo-offset fundamentals. 4th ed. Bloomington, McKnight, 1980. 386p. illus.

170. Courmont, Emile. La photogravure; histoire et technique. Paris, Gauthier-Villars, 1947. 249p.

171. Flader, Louis and Mertle, J. S. Modern photo-engraving: a practical textbook on latest American procedures. Chicago, Modern Photo-engravers Publishers, 1948. 334p. illus.

172. Smith, William J. et al. Photo-engraving in relief. 2d ed. London, Pitman, 1947. 309p.

173. Vidal, Léon. Traité pratique de photogravure. Paris, 1900. 445p. plates.

174. Wilkinson, W. T. Photo-engraving, photo-lithography, collotype, and photogravure. 5th ed. London, Morland, Judd, 1894. 169p.

175. Wilson, Thomas A. The practice of collotype. London, Chapman and Hall, 1935. 96p.

Electronic Printing

176. Doebler, Paul D. "The electronic systems revolution." (In Graphic arts manual. N.Y., Arno Press, Musarts Publishing Corp., 1980. p.242-50)

177. Hattery, Lowell H. and Bush, George P., eds. Automation and electronics in publishing. Wash., D.C., Spartan Books, 1965. 206p. illus.

178. _____ and _____. Technological change in printing and publishing. N.Y., Spartan Books, 1973. 275p. illus.

179. International Conference of Printing Research Institutes, 14th, Marbella, Spain, 1977. Advances in printing science and technology; proceedings.... Ed. by W. H. Banks. London, Pentech Press, 1979. 455p.

Color Printing

180. Astrua, Massimo. Manual of colour reproduction for printing and the graphic arts. Hertfordshire, Fountain Press, 1973. 254p.

181. Audsley, George A. The art of chromolithography. N.Y., Scribner's, 1883. 24p. 44 plates.

182. Biegeleisen, Jacob I. The complete book of silk screen printing production. N.Y., Dover, 1963. 253p.

183. Burch, Robert M. Colour printing and colour printers. With a chapter on modern processes by William Gamble. N.Y., Baker and Taylor, 1910. 280p. illus.

184. Cartwright, Herbert M. and MacKay, Robert. Rotogravure; a survey of European and American methods. Lyndon, Ky., MacKay, 1956. 303p.

185. Clemence, Will. The beginner's book of screen process printing. London, Blandford Press, 1970. 88p. illus.

186. Earhart, John F. The color printer: a treatise on the use of colors in typographic printing. Cincinnati, Earhart and Richardson, 1892. 137p. illus. 90 colored plates.

187. Gerhard, Claus W. Prägedruck und Siebdruck. Stuttgart, Hiersemann, 1974. 239p.

A comprehensive work on history and practice of embossed printing and screen process printing.

188. Hunt, Robert W. The reproduction of colour. 3d ed. London, Fountain Press, 1975. 614p.

189. Kinsey, Anthony. Introducing screen printing. N.Y., Watson-Guptill, 1968. 95p.

190. Noble, Frederick. The principles and practice of colour printing. London, Office of "Printers Register," 1881. 174p.

191. Richmond, W. D. Colour and colour printing as applied to lithography, containing an introduction to the study of colour, an account of the general and special features of pigments employed, their manufacture into printing inks, and the principles involved in their application. London, Wyman, 1885? 169p.

192. Savage, William. Practical hints on decorative printing. London, 1822. 118p.

193. Schnauss, Julius. Collotype and photolithography. Tr. by E. C. Middleton. London, Iliffe, 1889. 170p.

194. Sipley, Louis W. A half century of color. N.Y., Macmillan, 1951. 216p.

195. Southworth, Miles. Pocket guide to color reproduction: communication and control. Livonia, N.Y., Graphic Arts Publishing Co., 1979. 109p. illus.

196. Stern, Harry. Silk screen color printing. N.Y., McGraw-Hill, 1942. 73p.

197. Wilson, Thomas A. Practice of collotype. Boston, Photographic Publishing Co., 1935. 96p.

198. Yule, John A. Principles of color reproduction.... N.Y., Wiley, 1967. 411p.

Reprography

199. Crowhurst, Les and Burton, Peter. Basic reprographic techniques. London, Lithographic Training Services, 1979. 333p. illus.

200. Hanson, Richard. The manager's guide to copying and duplicating. N.Y., McGraw-Hill, 1980. 225p. illus.

201. Hawken, William R. Copying methods manual. Chicago, Library Technology Program, American Library Association, 1966. 375p. illus. facs

202. Nasri, William Z. "Reprography." Encyclopedia of library and information science 25:230-39. 1978.

203. New, Peter G. Reprography for librarians. London, Clive Bingley, 1975. 109p. illus.

204. Tyrell, Arthur. Basics of reprography. London, Focal Press, 1972. 228p.

Printers' Manuals of Individual Countries

France

205. Bargilliat, Alain. L'imprimerie au xxe siècle. Paris, Presses Universitaires, 1967. 256p.

206. Boulard, Martin S. Le manuel de l'imprimeur. Paris, 1791. 100p.

207. Brun, Henri. Manuel pratique et abrégé de la typographie française. Paris, F. Didot, 1825. 233p.

208. Crapelet, George A. Etudes pratiques et littéraires sur la typographie. Paris, Crapelet, 1837. 404p.

209. Didot, Pierre F. Epître sur les progrès de l'imprimerie. Paris, 1784. 20p.

210. Dupont, Paul F. Essais pratiques d'imprimerie, précédés d'une notice historique. Typographie-lithographie. Paris, Dupont, 1849. 60p. and 141 plates.

211. Fertel, Martin D. La science pratique de l'imprimerie.... Saint Omer, The Author, 1723. 292p.

212. Fournier, Henri. Traité de la typographie. Paris, The Author, 1825. 323p. 2d ed., 1854. 4th ed. 1904. New editions in 1919 and 1925.

213. Lefevre, Pierre T. Guide pratique du compositeur d'imprimerie. Paris, Firmin Didot frères, 1855. 440p. New ed. in 1883.

214. Momoro, Antoine F. Traité élémentaire de l'imprimerie. Paris, 1793. 347p. 36 plates.

215. Thibaudeau, François. Manuel français de typographie moderne.... Paris, 1924. 583p. illus. plates.

Germany

216. Bass, Jakob, ed. Das Buchdruckerbuch. 5th ed. Stuttgart, 1953. 810p.

217. Bauer, Friedrich. Handbuch für Buchdrucker. Frankfurt, 1909. 612p. illus.

 A classic treatment of the subject by a leading authority.

218. _____. Handbuch für Schriftsetzer. Frankfurt, 1938. 312p.

219. Franke, Carl A. Katechismus der Buchdruckerkunst. Leipzig, J. J. Weber, 1856. 166p.

220. Hasper, Wilhelm. Handbuch der Buchdruckerkunst. Carlsruhe, D. R. Marx, 1835. 362p.

221. Heller, Alfred. Der Organisation der Buchdruckerei. Leipzig, Poeschel, 1916. 214p.

222. Hornschuch, Hieronymus. Instructio operas typographicas correctures. Leipzig, Lantzenberger, 1608. 16, 45p. illus.

 Edited and translated into English by Philip Gaskell and Patricia Bradford in 1972.

223. Krebs, Benjamin. Handbuch der Buchdruckerkunst. Frankfurt, 1827. 830p. illus.

224. Tschichold, Jan. Typographische Gestaltung. Basel, Schwabe, 1935. 122p. illus.

225. Weber, Johann J. Katechismus der Buchdruckerkunst. 7th ed. Leipzig, The Author, 1901. 331p.

Great Britain

226. Avis, Frederick C. Printers' imposition. London, The Author, 1953. 144p.

227. Brewer, Roy. An approach to print; a basic guide to the printing processes. London, Blandford Press, 1971. 165p. illus. facs

228. Cowie, George. Cowie's pocket-book and manual containing the compositors' and pressmen's scale of prices. 2d ed. London, W. Strange, 1835? pages ?

 7th ed. (1847) has American scale of prices for compositors and pressmen.

229. Dowding, Geoffrey. Finer points in the spacing and arrangement of type. London, Wace, 1954. 62p. illus.

230. Hansard, Thomas C. Typographia; an historical sketch of the origin and progress of the art of printing with practical directions for conducting every department in an office.... London, Printed for Baldwin, Cradock and Joy, 1825. 939p. illus. plates.

231. Houghton, Thomas S. The printers' practical every-day book. London, 1841. 136p. illus. 2d ed., 1842.

232. Hutchings, Ernest A. A survey of printing processes. 2d ed. London, Heinemann, 1978. 246p. illus.

233. Jacobi, Charles T. Printing; a practical treatise on the art of typography as applied more particularly to the printing of books. London, G. Bell, 1890. 302p. illus. 6th ed., 1917.

234. Johnson, John. Typographia, or the printers' instructor. London, 1824. 2 vols. illus. plates.

235. Joyner, George. Fine printing: its inception, development, and practice. London, Cooper and Budd, 1895. 111p. illus. plates.

236. Luckombe, Philip. The history and art of printing.. London, Printed by W. Adlard and J. Browne for J. Johnson, 1771. 502p. illus.

237. Moxon, Joseph. Mechanick exercises; or the doctrine of handyworks. Applied to the art of printing. London, Printed for J. Moxon, 1683.

 An edition published by the Oxford University Press in 1958 was edited by Herbert Davis and Harry Carter.

238. Savage, William. A dictionary of the art of printing. London, 1841. 815p. illus.

239. Shepherd, Edward. Typography for students. London, MacDonald and Evans, 1958. 225p. illus.

240. Simon, Herbert. Introduction to printing; the craft of letterpress. London, Faber and Faber, 1980c1968. 120p. illus.

241. Smith, John. The printers' grammar.... London, 1755. Reprinted by the Gregg Press in 1965.

242. Southward, John. Practical printing. London, 1882. 634p. illus. 4th ed., 1892.

243. Stower, Caleb. The printer's grammar; or introduction to the art of printing.... London, Printed by the editor for B. Crosby, 1808. 530(48)p. illus. plates.

244. Timperley, Charles H. The printers' manual. London, H. Johnson, 1838. 115p.

Italy

245. Bodoni, Giovanni Battista. Manuale tipografico. Parma, Presso la Vedova, 1818. 2 vols.

 A photolithographic facsimile of this important manual was printed
 in Holland and published by the Holland Press in London in 1960.
 An English translation of the preface was published by E. Mathews
 in London in 1925.

246. Pozzoli, Giulio. Nuovo manuale di tipografia. Milan, 1882. 464p.

Spain

247. Giráldez, José. Tratado de la tipografia. Madrid, Eduardo Cuesta y Sanchez, 1884. 279p.

248. Sigüenza y Vera, Juan J. Mecanismo del arte de la imprenta. Madrid, 1811. 244p. 2d ed., 1822.

249. Ubieto Arteta, Antonio. Sobre tipografia: Apunte para investiga- dores. Valencia, Anubar, 1977. 116p.

United States

250. Adams, J. Michael and Faux, David D. Printing technology. 2d ed. North Scituate, Mass. Breton Publishers, 1982. 611p. illus.

251. Adams, Thomas F. Typographia; a brief sketch of the origin, rise, and progress of the typographic art with practical directions for con- ducting every department in an office. Phila., 1837. 372p. 2d ed., 1844. Later editions in 1845, 1851, and 1856.

252. Arnold, Edmund C. Ink on paper. N.Y., Harper, 1963. 323p.

253. De Vinne, Theodore L. The practice of typography: plain printing types. N.Y., Oswald, 1925. 403p.

254. Durrant, W. R. et al. Machine printing. N.Y., Hastings House, 1973. 245p.

255. Gress, Edmund G. The American handbook of printing. N.Y., Oswald, 1907. 284p. 3d ed., 1913.

256. Hurlburt, Allen. Layout: the design of the printed page. N.Y., Watson-Guptill, 1977. 159p. illus.

257. Kepes, György et al. Graphic forms; the arts as related to the book. Cambridge, Harvard Univ. Press, 1949. 128p.

258. Lee, Marshall. Bookmaking: the illustrated guide to design and production. N.Y., Bowker, 1965. 399p. 2d ed., 1979.

259. MacKellar, Thomas. The American printer: a manual of typography... 16th ed. Phila., MacKellar, Smiths and Jordan, 1887. 383p.

260. Martin, A. G. Finishing processes in printing. N.Y., Hastings House, 1972. 284p.

261. Melcher, Daniel and Larrick, Nancy. Printing and promotion handbook. 3d ed. N.Y., McGraw-Hill, 1966. 451p.

262. Mergenthaler Linotype Co. The manual of linotype typography. Brooklyn, 1923. 256p.

263. Rice, Stanley. Book design: text format models. N.Y., Bowker, 1978. 215p.

264. _____. Type-caster: universal copyfitting. N.Y., Van Nostrand Reinhold, 1980. 90p.

265. Skillin, Marjorie E. et al. Words into type. rev. ed. N.Y., Appleton-Century-Croft, 1964. 596p.

266. Turnbull, Arthur T. and Baird, Russell N. The graphics of communication. 4th ed. N.Y., Holt, Reinhart and Winston, 1980. 398p.

267. Van Winkle, Cornelius S. Printers' guide. N.Y., Printed and published by C. S. Van Winkle, 1818. 229p. 3d ed., 1836.

3

PRINTING MACHINERY
AND MATERIALS

History

268. Baker, Daniel, comp. Platen printing presses.... Chicago, United Typothetae of America, 1918. 42p. illus.

269. Diderot, Denis. "Printing." (In A Diderot pictorial encyclopedia of trades and industry. Ed. by C. L. Gillespie. N.Y., Dover, 1959. vol. 2, p.369-78)

270. Ducrot, André. Presses modernes typographiques. Paris, Gauthier-Villars, 1904. 161p. 141 illus.

271. Faulmann, Karl. Illustrierte Geschichte der Buchdruckerkunst. Vienna, A. Hartlebens, 1882. 806p. 380 illus. 14 colored plates.

See chapt. 21 for illustrations of machines.

272. Ganderton, Vernon S. and Copeland, Harry. Cylinder presses. 2d ed. London, Pitman, 1965. 65-144p. illus.

273. Gaskell, John P. W. "The decline of the common press." Ph.D. dissertation, King's College, Cambridge, 1956.

274. Great Britain. Patent Office. Patents for invention, Abridgements of specifications relating to printing, including therein the production of copies on all kinds of materials, by means of types, stereotype, blocks, plates, stone.... London, Eyre and Spottiswoode, 1859. 631p. (Reprint in 1969)

275. Green, Ralph. A history of the platen jobber. Chicago, P. Reed, 1953. 38p.

276. Harrild and Sons, London. Catalogue of printing machinery and materials. London, ca.1895.

277. Hoe, Robert. A short history of the printing press.... N.Y., The Author, 1902. 89p.

278. Hoe, firm, N.Y. Catalogue of printing presses and printers' materials. N.Y., 1881. 76p. illus. plates.

279. Höhne, Otto. Geschichte der Setzmachinen. Leipzig, 1925. 240p. illus.

280. Holtzapffel, Charles. Printing apparatus for the use of amateurs. Reprinted from the third greatly enlarged edition of 1846. Ed. by James Mosley and David Chambers. Pinner, England, Private Libraries Association, 1971. 79p.

281. Huss, Richard E. The development of printers' mechanical typesetting methods 1822-1925. Charlottesville, Published for the Bibliographical Society of the University of Virginia by the Univ. Press of Virginia, 1973. 307p. illus.

282. Kollecker, Eugen and Matuschke, Walter. Der modern Druck. Handbuch der graphischen Techniken. 2d ed. Hamburg, Hammerich and Lesser, 1958. 696p. illus.

283. Legros, Lucien A. and Grant, John C. Typographical printing surfaces; the technology and mechanism of their production. London, Longmans, Green, 1916. 732p. illus. 109 plates.

284. Lindner, Ernest A. The Ernest A.Lindner collection of antique printing machinery. Pasadena, Calif., The Weather Bird Press, 1971. 44p. illus.

285. Madan, Falconer. "Early representations of the printing press." Bibliographica 1:223-48. 1895.

286. Meier, Henry. "The origin of the printing and roller press." Print collector's quarterly 28:9-56, 165-206, 339-74, 497-528, Feb.-Dec. 1941.

287. Mengel, Willi. Ottmar Merganthaler and the printing revolution. Brooklyn, Mergenthaler Linotype, 1954. 63p.

288. Mergenthaler, Ottmar. Biography of Ottmar Mergenthaler and history of the linotype, its invention and development. Baltimore, 1898. 71p.

289. Moll, Herbert. Das Setzmachinenbuch. Stuttgart, Blersch, 1960. 228p. illus.

290. Monet, Adolphe L. Les machines et appareils typographiques en France et à l'étranger suivi des procédés d'impression. Paris, 1878. 434p. illus.

291. Moran, James. The composition of reading matter; a history from case to computer. London, Wace, 1965. 84p.

292. _____. "A condensed history of the relief printing press." Black art 3, no.2:34-61, 1964.

293. _____. Printing presses: history and development from the fifteenth century to modern times. Berkeley, Univ. of California Press, 1973. 263p. illus.

294. Neipp, Lucien. Les machines à imprimer depuis Gutenberg. Paris, Club Bibliophile de France, 1951. 442p. illus.

295. Nuttall, Derek. A brief history of platen presses. 2d ed. Manchester, North Western Museum of Science and Industry, 1979. 10p. 8 pages of plates.

296. Oakes, Suzanne M. "Monastic printing presses past and present." M.A. thesis, Univ. of Sheffield, 1974.

297. Pollak, Michael. "The daily performance of a printing press in 1476, evidence from a Hebrew incunable." Gutenberg Jahrbuch 1974, p.66-76.

 See also Rosenthal, Abraham. "Some remarks on 'The daily perform-ance of a printing press in 1476.'" Gutenberg Jahrbuch 1979, p.39-50.

298. Pottinger, David T. "The history of the printing press." (In Wroth, Lawrence C., ed. A history of the printed book. N.Y., Limited Editions Club, 1938. p.323-44)

299. Roblin, Fred. "Printing press development 1450-1965." American pressman 75:1-118, Nov. 1965.

300. Seyl, Antoine. Les machines d'imprimerie hier et aujourd'hui. Brussels, Imprimerie Scientifique et Littéraire, 1928. 125p. illus.

301. Sherman, Frank M. The genesis of machine typesetting. Chicago, M. and L. Typesetting and Electrotyping Co., 1950. 52p. illus.

302. Sigüenza y Vera, Juan J. Mecanismo del arte de la imprenta. Madrid, 1811. 244p. 2d ed., 1822.

303. Smith, Adèle M. Printing and writing materials: their evolution. Phila., The Author, 1900. 236p. illus. plates. facs

304. Stewart, Alexander A. Compositors' tools and materials. Chicago, United Typothetae of America, 1918. 38p. illus.

305. Thompson, John Smith. History of composing machines. Chicago, Inland Printer Co., 1904. 200p. illus.

306. Waite, Harold E. "Old printing offices." Gutenberg Jahrbuch 1959, p. 158-64.

307. Wilson, Frederick J. and Grey, Douglas. A practical treatise on modern printing machinery and letterpress printing. London, Cassell, 1888. 455p.

308. Wolf, Hans J. Geschichte der Druckpressen. Frankfurt, Interprint, 1974. 350p. illus.

309. Young, Laurence W. Materials in printing processes. N.Y., Hastings House, 1972. 293p. illus.

United States

310. Bullen, Henry L. "The evolution of American printing presses."
American printer 83:68-73, July 1926.

311. Eckman, James. "America's composing machines; their inventors and
promoters." (In The heritage of the printer. Phila., North American
Publishing Co., 1965. vol. 1, p.3-40)

312. _____. The heritage of the printer. vol. 1. Phila., North
American Publishing Co., 1965. 209p. illus. facs

 The articles describe original and imported tools of the printer
 in America, with primary attention to the last half of the 19th
 century and the first third of the 20th century.

313. Green, Ralph. "Early American power printing presses." Studies in
bibliography 4:143-53. 1951/52.

314. _____. The iron hand press in America. Rowayton, Connecticut,
1948. 29p.

315. Hamilton, Frederick W. Type and presses in America; a brief
historical sketch of the development of type casting and press building
in the United States. Chicago, United Typothetae of America, 1918. 43p.

316. Hattery, Lowell H. and Bush, George P., eds. Technological change
in printing and publishing. Rochelle Park, N.J., Hayden Book Co., 1973.
275p. illus.

317. Hoe, firm, N.Y. Catalogue of printing presses and printers'
materials. N.Y., 1881. 76p. illus. plates.

318. Huss, Richard E. The development of printers' mechanical type-
setting methods 1822-1925. Charlottesville, Published for the Biblio-
graphical Society of the University of Virginia by the Univ. Press of
Virginia, 1973. 307p. illus.

319. Oswald, John C. "The equipment and supplies of early American
printers." American printer 89:56-58, Oct. 1929.

320. _____. "The story of the typographic printing press." American
printer 83:54-57, Sept. 1926.

321. Oswald Publishing Co., N.Y. The American manual of presswork.
N.Y., 1911. 155p. illus. plates.

322. Polscher, A. A. "The early wooden hand printing press in the
United States." Black art 3, no.4:101-02. 1964/65.

323. Silver, Rollo G. "The costs of Mathew Carey's printing equipment."
Studies in bibliography 19:85-122. 1966.

324. _____. "Efficiency improved: the genesis of the web press in
America." Procs of the American Antiquarian Society 80, pt. 2:325-50.
1970.

325. Sterne, Harold E. Catalogue of nineteenth century printing presses. Cincinnati, Ohio, Ye Olde Printery, 1978. 382p. illus.

326. Stewart, Alexander A. Compositors' tools and materials. Chicago, United Typothetae of America, 1918. 38p. illus.

327. Tolman, R. P. "Printing presses of past days as they are exhibited in the U. S. National Museum at Washington." American printer 80:27-33, Apr. 5, 1925.

328. Vallette, M. F. "First printing press in America." American Catholic quarterly 46:669-77, Oct. 1921.

329. Wentscher, E. Maschinen der amerikanischen Druck-Industrie. Berlin, Verlag der Papier-Zeitung, 1897. 311p. illus.

330. Young, Laurence W. Materials in printing processes. N.Y., Hastings House, 1972. 293p. illus.

HISTORY OF BOOK PRINTING

General Works

331. ACRL. Rare Books and Manuscripts Section. Preconference in Boston, June 1980. Books and Society in history; papers of the Preconference. Ed. by Kenneth E. Carpenter. N.Y., Bowker, 1982.

332. Antique, modern and swash: a brief history of women in printing. N.Y., Club of Printing Women of N.Y., 1955. 60p.

333. Audin, Marius. Histoire de l'imprimerie par l'image. Paris, Jonquières, 1928-29. 4 vols.

334. _____. Histoire de l'imprimerie; radioscopie d'une ère: de Gutenberg à l'informatique. Paris, Picard, 1972. 480p.

335. Bartlett, Edward E. The typographic treasures in Europe, and a study of contemporaneous book production in Great Britain, France, Germany, Holland, and Belgium, with an addendum by J. W. Muller giving the principal dates and personages in printing history. N.Y., Putnam, 1925. 185p.

336. Bauer, Konrad. Aventur and Kunst; eine Chronik des Buchdruckgewerbes von der Erfindung der beweglichen Letter bis zur Gegenwart. Frankfurt, Privatdruck der Bauersche Giesserei, 1940. 437p. illus.

337. Bennett, Paul A., ed. Books and printing; a treasury for typofiles. rev. ed. Cleveland, World, 1963. 430p. illus.

338. Blumenthal, Joseph. "The great printers and their books." (In Art of the printed book 1455-1955; masterpieces of typography through five centuries from the collections of the Pierpont Morgan Library. N.Y., 1973. p.2-51)

339. Bockwitz, Hans H. Beiträge zur Kulturgeschichte des Buches. Leipzig, Harrassowitz, 1956. 162p. illus.

340. Bogeng, Gustav A. Geschichte der Buchdruckerkunst. Dresden, Demeter-Verlag, 1928-41. 2 vols. (vol. 2 by Hermann Barge)

341. Bouchot, Henri F. The printed book; its history, illustration and adornment.... Tr. and enl. by Edward C. Bigmore. London, Grevel, 1887. 312p. illus. facs

342. Cerná-Slapáková, Marie L. Strucné dejny knihtisku. Prague, Solc a Simácek, 1948. 224p.

343. Chappell, Warren. A short history of the printed word. N.Y.,
Knopf, 1971.

344. Cim, Albert. Le livre, Historique--fabrication--achat--classement--
usage et entretien. Paris, Flammarion, 1905-08. 5 vols.

345. Clair, Colin. A history of European printing. London, Academic
Press, 1976. 526p. illus.

 Appendix I: "Establishment of early presses in Europe--15th
 century," p.431-34; Appendix II: "When and where the first books
 were printed," p.435-46.

346. Clancy, M. T. "Looking back from the invention of printing."
Quarterly journal of the Library of Congress 39:169-83, Summer 1982.

347. Dahl, Svend. History of the book. 2d ed. Metuchen, Scarecrow
Press, 1968. 299p.

348. Dibdin, Thomas F. The bibliographical decameron. London,
Shakespeare Press, 1817. 3 vols. illus.

349. Diderot, Denis and Alembert, Jean d'. Diderot's Encyclopédie.
A facsimile reproduction of articles and plates with an introduction by
G. G. Barber. Ed. by Giles Barber. Farnborough, Gregg International,
1973.

350. Dupont, Paul F. Histoire de l'imprimerie. Paris, The Author,
1854. 2 vols.

351. Deleted.

352. Eisenstein, Elizabeth L. "The advent of printing in current
historical literature...." American historical review 75:727-43, Feb.
1970.

353. _____. Printing press as an agent of change; communications
and cultural transformations in early modern Europe. Cambridge, Univ.
Press, 1979.

 "... a bold (and, in my view, largely successful) attempt to
 assess the impact of printing on the intellectual life of the
 West."--John Feather in Library, March 1980, p.15.

354. _____. "Some conjectures about the impact of printing on
western society and thought; a preliminary report." Journal of modern
history 40:1-56, Mar. 1968.

355. Escarpit, Robert et al. "La recherche sur le livre." Tendances
no.77:265-80. 1972.

356. Escolar Sobrino, Hipólito. Historia del libro en cinco mil palabras.
Madrid, Asociacion Nacional de Bibliothecarios, Archivos y Arqueologos,
1972. 60p. plates.

357. Faulmann, Karl. Illustrierte Geschichte der Buchdruckerkunst.
Vienna, Hartlebens, 1882. 806p. 380 illus. 14 plates in color.

358. Febvre, Lucien P. and Martin, Henri-Jean. L'apparition du livre.
Paris, Albin Michel, 1958. 557p. plates.

 Contains a long bibliography (p.499-528) and many titles in the
 footnotes.

359. _____. The coming of the book; the impact of printing 1450-1800.
Tr. by David Gerard. Ed. by Geoffrey Nowell-Smith and David Wootton.
London, NLB, 1976. 378p.

 A translation of L'apparition du livre (see above)

360. Fleuron anthology. Chosen and with a retrospectus by Francis
Meynell and Herbert Simon. London, Ernest Benn, 1973. 359p. illus.

361. Flocon, Albert. L'univers des livres. Etudes historiques des
origines à la fin du xviii⁻siècle. Paris, Hermann, 1961. 706p. illus.

 Issued as supplement to Bibliographie de la France, part 2
 (chronique), Mar. 4, 1960-June 16, 1961.

362. Funke, Fritz. Über Buchkunde; ein Überlich die Geschichte des
Buch und Schriftwesens. Leipzig, Harrassowitz, 1959. 308p. illus.
4th ed., 1978.

363. Harter, Evelyn. Printers as men of the world. N.Y., Printed for
the Typofiles, 1947. 59p.

364. Howe, Ellic, comp. "The trade" literature of the printing craft
1550-1935. London, Private printing for the benefit of the funds of the
printers' pension, almshouse and orphan asylum corp., by W. Hutchinson,
1943. 151p.

365. Hussmann, Heinrich. Über das Buch; Aufzeichnungen aus meinen
Vorlesungen. Wiesbaden, Pressler, 1968. 108p. illus.

366. Iguiniz, Juan B. El libro; epítome de bibliología. Mexico,
Editorial Porrua, S.A., 1946. 288p. illus. facs

367. Indiana University. Lilly Library. Exotic printing and the
expansion of Europe 1492-1840. Bloomington, 1972. 81p. illus.

 Covers India, Japan, Latin America, Philippines, Indonesia, Ceylon,
 and Macao.

368. Jackson, Holbrook. The printing of books. 2d ed. London, Cassell,
1947. 285p. illus. facs

369. Jennett, Sean. Pioneers in printing. London, Routledge and Kegan
Paul, 1958. 196p.

370. Johnson, Alfred F. Selected essays on books and printing. Ed. by
Percy H. Muir. Amsterdam, Van Gent, 1970. 489p. illus.

371. Johnson, Elmer D. Communication; an introduction to the history
of the alphabet, writing, printing, books and libraries. 2d ed. N.Y.,
Scarecrow Press, 1960. 251p.

372. Katsprzhak, Evgeniia I. Istoriia knigi. Moscow, Kniga, 1964.
421p. illus. facs

373. Labarre, Albert. Historie du livre. Paris, Presses Universitaires
de France, 1970. 128p.

374. La Caille, Jean de. Histoire de l'imprimerie et de la librairie.
Paris, The Author, 1689. 322, 26p.

375. Lange, Wilhelm H. Das Buch im Wandel der Zeiten. 6th ed.
Frankfurt, Büchergilde Gutenberg, 1951. 296p.

376. Lechêne, Robert. L'imprimerie de Gutenberg à l'électron. Paris,
La Farandole, 1965. 109p. illus.

377. _____. "Printing." Encyclopedia Britannica. 15th ed.
Macropedia 14:1051-74. 1974.

378. Le Moine, Henry. Typographical antiquities; history, origin, and
progress of the art of printing. London, S. Fisher, 1797. 156p.

379. Levarie, Norma. The art and history of books. N.Y., Heinemann,
1968. 315p. facs

380. Lewis, John N. The anatomy of printing; the influences of art and
history on its design. London, Faber and Faber, 1970. 228p. illus.
plates.

381. Lorck, Carl B. Handbuch der Geschichte der Buchdruckerkunst.
Leipzig, Weber, 1882-83. 2 vols. in 1.

382. Luckombe, Philip. The history and art of printing. London,
Printed by W. Adlard and J. Browne for J. Johnson, 1771. 502p. illus.

383. McLuhan, Herbert M. The Gutenberg galaxy; the making of typographic
man. Toronto, Univ. of Toronto Press, 1962. 293p.

384. McMurtrie, Douglas C. The book; the story of printing and book-
making. 3d ed. London, Oxford Univ. Press, 1943. 676p. illus.

385. Marinis, Tammaro de. "Tipografia." Enciclopedia italiana
33:887-907. 1937.

386. Martin, Henri-Jean. Le livre et la civilisation écrite. Paris,
Ecole Nationale Supérieure de Bibliothécaires, 1968-

387. Mello, José B. Sintese histórica de livre. Rio de Janeiro,
Editora Leitura, 1972. 341p. illus.

388. Morison, Stanley. Four centuries of fine printing. 4th ed. N.Y.,
Barnes and Noble, 1960. 254p. many plates.

389. Morison, Stanley and Jackson, Holbrook. A brief survey of print-
ing: history and practice. N.Y., Knopf, 1923. 87p. illus.

Morison enlarged and revised it slightly for the 1962 ed.

390. Mumby, Frank A. and Norrie, Ian. Publishing and bookselling; a
history from the earliest times to the present day. 5th ed. London,
Cape, 1974. 685p.

391. Nemirovskii, Evgeny L. Roshdenie knigi. Moscow, Kniga, 1964.
377p.

392. Peddie, Robert A., ed. Printing: a short history of the art.
London, Grafton, 1927. 390p.

393. Pottinger, David T. Printers and printing. Cambridge, Harvard
Univ. Press, 1941. 143p. illus. plates.

394. Presser, Helmut. Buch und Druck: Aufsätze und Reden. Krefeld,
Scherpe, 1974. 163p.

395. _____. Das Buch vom Buch: 5000 Jahre Buchgeschichte.
Hannover, Schluter, 1978. 260p. illus.

396. Putnam, George H. Books and their makers during the Middle Ages.
N.Y., Putnam, 1896. 2 vols.

Volume 2 covers the period 1500-1709.

397. Quayle, Eric. The collector's book of books. N.Y., Clarkson N.
Potter, 1971. 143p. illus. facs

398. Renner, Paul. Der Künstler in der mechanisierten Welt. Munich,
Akademie für das Grafische Gewerbe, 1977. 229p.

399. Rodenberg, Julius. Die Druckkunst als Spiegel der Kultur in fünf
Jahrhunderten. Berlin, 1942. 568p. plates. facs

400. _____. "Zur Architektonik des Buches." (In Alere Flammam.
[Georg Minde-Pouet zum fünfzigsten Geburtstage....] Leipzig, Gesellschaft
der Freunde der Deutschen Bücherei, 1921. p.91-102)

401. Rosarivo, Raúl M. Historia general del libro impreso. Buenos
Aires, Ediciones Aureas, 1964. 293p. illus.

402. Sayce, Richard A. "Compositorial practices and the localization of
printed books." Library 21:1-45, Mar. 1966.

Article suggests "methods of placing and dating printed books which
do not depend on a specialized knowledge of the history of printing."
(page 1) Reprinted with addenda and corrigenda by the Oxford
Bibliographical Society in 1979.

403. Schottenloher, Karl. Das alte Buch. 3d ed. Braunschweig,
Klinkhardt and Burmann, 1956. 467p. illus. facs

404. Schottenloher, Karl. Bücher bewegten die Welt; eine Kulturgeschichte des Buches. Stuttgart, Hiersemann, 1968. 2 vols.

405. Sidorov, Aleksei A. Kniga i zhizn. Moscow, Kniga, 1972. 231p.

406. Stanciu, Ilie. Călătorie în lumea cărti; mica enciclopedia illustrata. Bucharest, Editura Didactica si Pedagogica, 1970. 319p. illus. facs

407. Steinberg, Sigfrid H. Five hundred years of printing. 2d ed. Harmondsworth, Penguin Books, 1961. 394p. illus. 3d ed. rev. by James Moran in 1974.

408. Taylor, Archer and Arlt, Gustave O. Printing and progress; two lectures. Berkeley, Univ. of California Press, 1941. 67p.

409. Thomas, Alan G. Fine books. London, Weidenfeld and Nicolson, 1967. 120p. illus.

410. Tschichold, Jan. Bokens proportioner. Gothenberg, Sweden, Wezäta, 1955. 47p. facs

411. Vervliet, Hendrik D. L. "Gutenberg or Diderot?" Quaerendo 8, no.1:3-28, winter 1978.

 On schools of thought relating to the importance of printing.

412. _____, ed. The book through five thousand years; a survey by Fernand Baudin and others. London, Phaidon, 1972. 496p. illus. facs

413. Widmann, Hans. Geschichte des Buchhandels vom Altertum bis zur Gegenwart. Wiesbaden, Harrassowitz, 1975-

414. Winckler, Paul A., ed. Reader in the history of books and printing. Englewood, Colo., Information Handling Services, 1978. 406p.

415. Wroth, Lawrence C., ed. A history of the printed book, being the third number of the Dolphin. N.Y., Limited Editions Club, 1938. 507, 31p. illus.

Early History to the Seventeenth Century

Reference Works

416. Besterman, Theodore. Early printed books to the end of the sixteenth century: a bibliography of bibliographies. 2d ed. Geneva, Societas Bibliographica, 1961. 344p.

417. British Museum. Dept. of Printed Books. Catalog of books printed in the xvth century now in the British Museum. London, 1962- plates. facs

418. Burger, Konrad. "Printers and publishers of the 15th century." (In Copinger, Walter A. Supplement to Hain's Repertorium bibliographicum. Berlin, Altmann, 1926. vol. 2, p.319-670)

419. Bustamente y Urrutia, José M. de. Catálogos de la Biblioteca Universidad Santiago de Compostela. Santiago, 1944-48. 243 facs

420. Clair, Colin. "Establishment of early presses in Europe--15th century." (In A history of European printing. London, Academic Press, 1976. p.431-34)

421. _____. "When and where the first books were printed." (In Clair, Colin. A history of European printing. London, Academic Press, 1976. p.435-46)

422. Fava, Domenico. Manuale degli incunabuli. 2d ed. Milan, Görlich, 1953. 286p. illus.

423. Haebler, Konrad. Handbuch der Inkunabelkunde. Leipzig, Hiersemann, 1925. 187p.

424. _____. The study of incunabula. Tr. from the German by Lucy Eugenia Osborne. N.Y., Grolier Club, 1933. 241p.

425. Josephson, Aksel G. "The literature of the invention of printing." Papers of the Bibliographical Society of America 11:1-14. 1917.

426. McMurtrie, Douglas C. The invention of printing: a bibliography. Chicago, Chicago Club of Printing House Craftsmen, 1942. 413p.

427. Malclès, Louise N. L'imprimerie et le livre aux xve et xvie siècles." (In Les sources du travail bibliographique. Geneva, E. Droz, 1950. vol. 1, p.40-73)

428. Montiel, Isidoro. Incunables de la Biblioteca Pública Provincial de Huesca; catálogo descriptivo y anotado. Madrid, 1949. 308p. plates.

429. Peddie, Robert A. Fifteenth-century books; a guide to their identification. With a list of the Latin names of the towns and an extensive bibliography of the subject. London, Grafton, 1913. 89p.

430. Pellechet, Marie L. Catalogue générale des incunables des bibliothèques publiques de France. Paris, A. Picard et fils, 1897-1909. 3 vols.

 Later vols. on 11 reels of microfilm.

431. Pforzheimer, Carl H. The Carl H. Pforzheimer library. N.Y., 1940. 3 vols. plates. facs

432. Pilinski, Adam, ed. Monuments de la zylographie. Reproduits en facsimilé. Paris, Pilinski et fils, 1882-86. 8 vols.

433. Sajó, Géza and Soltész, Erzsébet, eds. Catalogus incunabulorum quae in bibliothecis publicis Hungaricae asservantur. Budapest, In aedibus Academiae Scientarium Hungaricae, 1970. 2 vols. 78 facs

434. Spencer, George J., 2d Earl, 1758-1834. Bibliotheca Spenceriana; a descriptive catalogue of the library of George John, Earl Spencer.... by Rev. Thomas F. Dibdin. London, 1814-23. 7 vols. illus. plates. facs

435. Stillwell, Margaret B. The beginning of the world of books 1450 to 1470; a chronological survey of the texts chosen for printing during the first twenty years of the printing art. With a synopsis of the Gutenberg documents. N.Y., Bibliographical Society of America, 1972. 112p.

436. Type Facsimile Society. Publications 1900-1909. London, 1900-1909.

Contains facsimiles of incunabula.

General Works

437. Allen, Don C. "Some contemporary accounts of renaissance printing methods." Library 17:167-71, Sept. 1936.

438. Barker, Nicolas. "The invention of printing; revolution within revolution." Quarterly journal of the Library of Congress 35:64-76, Apr. 1978.

439. Bernard, Auguste J. De l'origine et les débuts de l'imprimerie en Europe. Paris, 1853. 2 vols. plates.

440. Bühler, Curt F. Early books and manuscripts; forty years of research. N.Y., Grolier Club and the Pierpont Morgan Library, 1973. 659p.

441. _____. The fifteenth century book; the scribes, the printers, the decorators. Phila., Univ. of Pennsylvania Press, 1960. 195p. illus.

442. Butler, Pierce. The origin of printing in Europe. Chicago, Univ. of Chicago Press, 1940. 154p. illus. facs

443. De Vinne, Theodore L. The invention of printing.... N.Y., Hart, 1876. 556p. 2d ed., 1878.

444. Doyle, Anthony I. et al. Manuscript to print; tradition and innovation in the Renaissance book. Durham, England, University Library, 1975. 32p. illus.

445. Eisenstein, Elizabeth L. "The advent of printing and the problem of the Renaissance." Past and present 45:19-89, Nov. 1969.

446. _____. "The early printer as a Renaissance man." Printing history 3, no.1:6-18. 1981.

447. Goldschmidt, Ernst P. The printed book of the Renaissance; three lectures on type, illustration, ornament. Cambridge, University Press, 1950. 92p. illus.

448. _____. Medieval texts and their first appearance in print. London, Printed for the Bibliographical Society at the University Press, Oxford, 1943. 143p.

Reprinted with corrections, Meisenheim, Germany, Hain, 1965.

449. Grolier Club, N.Y. A description of the early printed books owned by the Grolier Club with a brief account of their printers and the history of typography in the fifteenth century. N.Y., 1895. 77p. illus. facs

450. Hellinga-Querido, Lotte. "Methods en praktijk bij het zetten van boeken in de vijftiende de eeuw." Dissertation, Univ. of Amsterdam, 1974. 271p.

On the technique of composing books in the 15th century.

451. _____. "Notes on the order of setting a fifteenth century book." Quaerendo 4:64-69. 1974.

452. Hindman, Sandra and Farquhar, James D. Pen to press; illustrated manuscripts and printed books in the first century of printing; an exhibition at the University of Maryland Art Dept. Gallery, College Park, Md., Sept. 15-Oct. 23, 1977. Art Dept., Univ. of Maryland and the Dept. of the History of Art, Johns Hopkins Univ., 1977. 234p. 89 facs

453. Hirsch, Rudolf. "The emergence of printing and publishing as a trade 1450-1550." Ph.D. dissertation, Univ. of Pennsylvania, 1955. 194p.

454. _____. The printed word: its impact and diffusion (primarily in the 15th-16th centuries). London, Variorum Reprints, 1978. various pagination.

455. _____. Printing, selling, and reading 1450-1550. Wiesbaden, Harrassowitz, 1967. 165p.

456. Jackson, William A. "Proofreading in the sixteenth and seventeenth centuries." Colophon 1:254-60, autumn 1935.

457. Jennings, Oscar. Early woodcut initials, containing over thirteen hundred reproductions of ornamental letters of the fifteenth and sixteenth centuries. London, Methuen, 1908. 287p.

458. Johnson, Alfred F. "The sixteenth century." (In Wroth, Lawrence C., ed. A history of the printed book. N.Y., Limited Editions Club, 1938. p.121-56)

459. Kingdon, Robert M. "Patronage, piety and printing in sixteenth-century Europe." (In Pinkney, David H. and Ropp, Theodore, eds. A festschrift for Frederick B. Artz. Durham, Duke Univ. Press, 1964. p.19-36)

460. Lenkey, Susan V. "Migrations of sixteenth century printers." Gutenberg Jahrbuch 1978, p.218-23.

461. _____. "Printer's wives in the age of humanism." Gutenberg Jahrbuch 1975, p.331-37.

462. McMurtrie, Douglas C. The corrector of the press in the early days of printing. Greenwich, Conn., Condé Nast Press, 1922. 15p.

463. _____. Miniature incunabula. Chicago, 1929. 11p.

464. Mallinckrodt, Bernard von. De ortu ac progressu artis typo-
graphicae.... Cologne, 1639-40. 125p.

 One of the earliest books devoted entirely to the history of
printing.

465. Marchand, Prosper. Histoire de l'origine et des premiers progrès
de l'imprimerie. La Haye, P. Paupie, 1740. 152p. Supplement by
Mercier in 1773. Rev. and augmented in 1775.

466. Marinis, Tammaro de. Appunti e ricerche bibliografiche. Milan,
Hoepli, 1940. 159p. 272 facs

467. Mazal, Otto. Buchkunst der Gotik. Graz, Akademische Druck- und
Verlagsanstalt, 1975. 253p. 54 leaves of plates.

468. Meerman, Gerard. Origines typographicae. Hagae Comitum, N. van
Daalen, 1765. 2 vols in 1.

469. Mellottée, Paul. Histoire économique de l'imprimerie. vol. 1.
Paris, Hachette, 1905. 531p. illus. plates.

470. Mortet, Charles. Les origines et les débuts de l'imprimerie
d'après les recherches les plus récentes. Paris, 1922. 98p.

471. Mortimer, Ruth. "The dimensions of the Renaissance title page."
Printing history 2, no.1:34-46. 1981.

472. Philadelphia. Free Library. The first printers and their books;
a catalogue of an exhibition commemorating the five hundredth anniversary
of the invention of printing. Compiled by Elizabeth Morgan and Edwin
Wolf, 2d. Phila., 1940. 94p. illus.

473. Pollak, Michael. "Production costs in fifteenth century printing."
Library quarterly 39:318-30, Oct. 1969.

474. Pollard, Alfred W. "Margins." Dolphin no.1:67-80. 1933.

 On the measurement of margins in early printed books and the
19th century.

475. Praloran, Giovanni. Delle origini e del primato della stampa tipo-
grafica. Milan, 1868. 172p. illus.

476. Proctor, Robert G. The printing of Greek in the fifteenth century.
Oxford, Univ. Press, 1900. 217p. illus.

477. Ratcliffe, F. W. "Margins in the manuscript and printed book."
Penrose annual 59:217-34. 1966.

478. Rath, Erich von. "The spread of printing in the fifteenth century."
(In Wroth, Lawrence C., ed. A history of the printed book. N.Y., Limited
Editions Club, 1938. p.59-120)

479. Scholderer, Victor. "The invention of printing." (In Fifty essays in fifteenth and sixteenth century bibliography. Ed. by Dennis E. Rhodes. Amsterdam, Hertzberger, 1966. p.156-68)

480. _____. "Red printing in early books." Gutenberg Jahrbuch 1958, p.165-07.

 Additional information in Gutenberg Jahrbuch 1959, p.59-60.

481. Shaaber, Matthias A. "The meaning of the imprint in early printed books." Library 24:120-41. Dec. 1943.

482. _____. "Notes on some printing-house practices in the sixteenth century." Library chronicle (Univ. of Pennsylvania) 40:124-39, winter 1974.

 On placing and dating printed books.

483. Simpson, Percy. Proofreading in the sixteenth, seventeenth, and eighteenth centuries. London, Oxford Univ. Press, 1935. 251p.

484. Slater, John R. Printing and the Renaissance. N.Y., W. E. Rudge, 1921. 35p.

485. Uhlendorf, B. A. "The invention of printing and its spread till 1470 with special reference to social and economic factors." Library quarterly 2:179-231, July 1932.

486. Utrecht. Rijks-universiteit Bibliotheek. Incunabeln, beschreven door Dr. J. Alblas en uitgegeven met toelichtende aanteekeningen, platen en facsimiles door J. F. van Someren. Utrecht, 1922. 230p. plates. facs

487. Vervliet, Hendrik D. L. "Printing in the fifteenth and sixteenth centuries." (In The book through five thousand years. Ed. by H. D. L. Vervliet. London, Phaidon, 1972. p.355-82)

488. Voet, Léon. The making of books in the Renaissance as told by the Plantin-Moretus Museum. N.Y., American Friends of the Plantin-Moretus Museum, 1966. 62p. illus.

489. Winship, George P. Printing in the fifteenth century. Phila. Univ. of Pennsylvania Press, 1940. 158p. facs

490. Wroth, Lawrence C. "Printing and the rise of modern culture in the fifteenth century." (In Typographic heritage. N.Y., The Typofiles, 1949. p.5-28)

Block books

491. Berjeau, Jean P. Catalogue illustré des livres xylographiques. London, C. J. Stewart, 1865. 116p. facs

492. Binns, Norman E. "Block books and the invention of printing with movable types." (In An introduction to historical bibliography. 2d ed. London, Association of Assistant Librarians, 1962. p.46-61)

493. Carter, Thomas F. "The westward course of block printing." (In
The invention of printing in China and its spread westwards. 2d ed.
N.Y., Ronald Press, 1955. p.119-208)

494. Donati, Lamberto. "Osservazioni sui libri xilografici." (In
Studi di bibliografia e di storia: In onore di Tammaro de Marinis.
Verona, Valdonega, 1964. vol. 2, p.207-64)

495. Einblattdrücke des fünfzehnten Jahrhunderts. Ed. by Paul Heitz.
Strassburg, J. H. E. Heitz, 1899-1942.

496. Hanover. Neidersächsische Landesbibliothek. Xylographische und
typographische Incunabeln der Königlichen Offentlichen Bibliothek zu
Hanover. Beschrieben von Eduard Bodemann. Hanover, Hahn, 1866. 130p.
plates.

497. Hind, Arthur M. An introduction to a history of the woodcut, with
a detailed survey of work done in the 15th century. London, Constable,
1935. 2 vols. 483 illus.

498. Kraus, H. P., firm. Monumenta xylographica et typographica: the
cradle of printing, pt.2, catalogue 131. N.Y., 1971. 167p. illus.

499. Mann, Charles W. "Block printing." Encyclopedia of library and
information science 2:638-44. 1969.

500. Musper, Heinrich T. Der Einblattholzschnitt und die Blochbücher
des 15. Jahrhunderts. Stuttgart, Hiersemann, 1976. 84p. 218 plates.

501. _____. "Xylographic books." (In Vervliet, Hendrik D. L., ed.
The book through five thousand years. London, Phaidon, 1972. p.341-47)

502. Schreiber, Wilhelm L. Manuel de l'amateur de la gravure sur bois
et sur métal au xve siècle. Berlin, A. Cohn, 1891-1911. 8 vols in 9.
illus. plates.

 Vols. 7 and 8 have facsimiles from block books.

503. _____. Woodcuts from books of the 15th century shown in
original specimens. Munich, Weiss, 1929. 83p. 55 mounted plates.

504. Sotheby, Samuel L. Principia typographica. London, 1858. 3 vols.
120 plates.

 Contains facsimiles from block books issued in Flanders, Holland,
 and Germany.

Seventeenth and Eighteenth Centuries

505. Baudin, Fernand and Lemaire, Claudine. "Fine books in the seven-
teenth century." (In Vervliet, Hendrik D. L., ed. The book through 5000
years. London, Phaidon, 1972. p.383-409)

506. Chapman, Robert W. "Notes on eighteenth century bookbuilding."
Library 4:165-80, Dec. 1923.

507. Crutchley, Brooke. "Caxton and after; the visual impact of print-
ing." Royal Society of Arts journal 125:70-86, Jan. 1977.

508. Hamill, Frances. "Some unconventional women before 1800: printers,
booksellers, and collectors." Papers of the Bibliographical Society of
America 49:300-14, 4th quarter 1955.

509. Indiana University. Lilly Library. Exotic printing and the
expansion of Europe 1492-1840. Bloomington, 1972. 81p. illus.

510. Jackson, William A. "Proofreading in the sixteenth and seventeenth
centuries." Colophon 1:254-60, autumn 1935.

511. Lemaire, Claudine. "Fine books in the eighteenth century." (In
Vervliet, Hendrik D. L., ed. The book through five thousand years.
London, Phaidon, 1972. p.410-26)

512. Phillips, J. W. "A bibliographical inquiry into printing and book-
selling from 1670 to 1800." Ph.D., Trinity College, Dublin, 1952.

513. Simpson, Percy. Proofreading in the sixteenth, seventeenth, and
eighteenth centuries. London, Oxford Univ. Press, 1935. 251p.

514. Stillwell, Margaret B. "The seventeenth century." (In Wroth,
Lawrence C., ed. A history of the printed book. N.Y., Limited Editions
Club, 1938. p.157-99)

515. Wroth, Lawrence C. "The eighteenth century." (In Wroth, Lawrence
C., ed. A history of the printed book. N.Y., Limited Editions Club,
1938. p.201-32)

Nineteenth Century

516. Beilenson, Peter. "The nineteenth century." (In Wroth, Lawrence
C., ed. A history of the printed book. N.Y., Limited Editions Club,
1938. p.233-67)

517. Carr, Francis. "An outline history of screen printing." British
printer 75:95-102, Sept. 1962.

518. Clair, Colin. "Art nouveau (Jugendstil) and after." (In A history
of European printing. London, Academic Press, 1976. p.415-25)

519. _____. "Nineteenth century printing in Europe." (In A history
of European printing. London, Academic Press, 1976. p.384-405)

520. De Vinne, Theodore L. "The printing of books." Outlook 57:805-09,
Dec. 4, 1897.

521. Dröge, Kurt. Die Fachsprache des Buchdrucks im 19. Jahrhundert.
Lemgo, Wagener, 1978. 404p.

522. Dunlap, Joseph R. "The road to Kelmscott: William Morris and the book arts before the founding of the Kelmscott Press." DLS, Columbia Univ., 1972.

523. Granniss, Ruth S. "Modern fine printing." (In Wroth, Lawrence C., ed. A history of the printed book. N.Y., Limited Editions Club, 1938. p.269-93)

524. Hasler, Charles. "Mid-nineteenth century colour printing." Penrose annual 45:66-68. 1951.

525. Hirsch, S. Carl. Printing from a stone; the story of lithography. N.Y., Viking Press, 1967. 111p.

526. Kautzsh, Rudolf, ed. Die neue Buchkunst; Studien im in- und ausland. Weimar, Gesellschaft der Bibliophilen, 1902. 200p.

527. Latimer, Henry C. Survey of lithography. N.Y., Lithographic Technical Foundation, 1956. 99p.

528. Lemaire, Claudine. "Fine books in the nineteenth century." (In Vervliet, Hendrik D. L., ed. The book through 5000 years. London, Phaidon, 1972. p.427-57)

529. Marthold, Jules de. Histoire de la lithographie. Paris, May, 1898. 64p.

530. Moran, Michael L. "The mechanization of printing 1805-1908." Master's thesis, Univ. of Chicago, 1965.

Twentieth Century

531. Archer, Horace R. and Ritchie, Ward. Modern fine printing. Los Angeles, William Andrews Clark Memorial Library, Univ. of California, 1968. 44p.

532. "Book making." (Printing in the twentieth century: a survey reprinted from the special no. of The Times, Oct. 29, 1929. London, 1930. p.67-91)

533. British Museum. Dept. of Printed Books. Catalogue of an exhibition of books illustrating British and foreign printing 1919-1929. London, 1929. 57p. plates.

534. Clair, Colin. "Modern trends in printing." (In A history of European printing. London, Academic Press, 1976. p.426-30)

535. Doebler, Paul D. "The electronic systems revolution." (In Graphic arts manual. N.Y., Arno Press, Musarts Publishing Corp., 1980. p.242-50)

536. Eckerstrom, Ralph E. Contemporary book design. Urbana, Illinois, Beta Phi Mu, 1953. 26p.

537. Gates, Yuri. "Present and future printing techniques." (In Hills, Philip, ed. The future of the printed word. Westport, Conn., Greenwood, 1980. p.123-34)

538. Gibson, Peter. Modern trends in letterpress printing. London, Studio Vista, 1966. 110p.

539. Grannis, Chandler B., ed. Heritage of the graphic arts; a selection of lectures delivered at Gallery 303, New York City under the direction of Dr. Robert L. Leslie. N.Y., Bowker, 1972. 291p.

 Contains essays on some of the leading typographers and printers of the 20th century.

540. Hattery, Lowell H. and Bush, George P., eds. Technological change in printing and publishing. N.Y., Spartan Books, 1973. 275p. illus.

541. _____ and _____. Automation and electronics in publishing. Wash., D.C., Spartan Books, 1965. 206p.

542. Hutchings, Ernest A. Survey of printing processes. 2d ed. London, Heinemann, 1978. 246p. illus.

543. Ibrahim, Karen. "The growth and status of automated typesetting." Graphic arts progress 15:4-11, Oct. 1968.

544. International Association of Printing House Craftsmen. Printing progress; a mid-century report. Cincinnati, 1959. 543p. illus. facs

545. International Conference of Printing Research Institutes, 14th, Marbella, Spain, 1977. Advances in printing science and technology.... Ed. by W. H. Banks. London, Pentech Press, 1979. 455p.

546. Jenkins, Nicholas. "Redesign book design." Penrose annual 63:159-68. 1970.

547. Johnston, Paul. Biblio-typographica; a survey of contemporary fine printing style. N.Y., Covici, Friede, 1930. 303p. facs

548. Kundig, P. and Braillard, E. Le livre contemporain. Geneva, Musée Rath, 1978. 140p. 130 illus. (exhibit catalog)

549. Lechêne, Robert. "Modern printing techniques." Encyclopedia Britannica 15th ed. Macropedia 14:1059-74. 1979.

550. Lewis, John N. The twentieth century book; its illustration and design. N.Y., Reinhold, 1967. 272p. illus.

551. Lilien, Otto M. Die Geschichte des Tiefdruckes von 1900-1920. Frankfurt, 1963. 137p.

552. McMurtrie, Douglas C. "Contemporary fine printing." (In The book; the story of printing and bookmaking. 3d ed. London, Oxford Univ. Press, 1943. p.484-99)

553. Modern book production; an international survey. Ed. by Charles
Holme. London, The Studio, 1928. 186p. plates. facs

554. Moran, James. "The techniques for the job." Times literary sup-
plement, Dec. 7, 1973, p.1499-1500.

 About printing between 1963 and 1973.

555. _____, ed. Printing in the 20th century: A Penrose anthology.
London, Northwood, 1974. 332p. illus.

556. Morison, Stanley. Modern fine printing; an exhibit of printing....
London, Benn, 1925. 152p. illus.

 The exhibit covered several European countries and the United
 States. The illustrations are mainly reproductions of title pages.

557. Raben, Joseph. "Electronic revolution and the world just around
the corner." Scholarly publishing 10:105-209, Apr. 1979.

558. Rice, Stanley. Book design--systematic aspects. N.Y., Bowker,
1978. 274p. illus.

559. Rossiter, William S. Growth of printing in the twentieth century.
Concord, Rumford Press, 1925. 24p.

560. Shotwell, Robyn. "Computerized page makeup: just around the
corner." Publishers' weekly 219:34-36, Apr. 10, 1981.

561. Symposium on printing. Edited by R. Reed. Leeds, Leeds Philosoph-
ical and Literary Society, 1971. 89p.

562. The Times (London). Printing in the twentieth century; a survey.
Reprinted from the special number of The Times, Oct. 29, 1929. London,
Times Publishing Co., 1930. 298p.

563. Wallis, L. W. "Typesetting metamorphoses." Penrose annual
64:176-88. 1971.

564. Walter, Gerard O. "Typesetting." Scientific American 220:60-69,
May 1969.

565. Williamson, Hugh. Methods of book design; the practice of an
industrial craft. 2d ed. London, Oxford Univ. Press, 1966. 433p.
illus. facs

566. Wilson, Adrian. The design of books. N.Y., Reinhold, 1967. 159p.
illus. facs

5

MAPS

Reference Works

567. Bonacker, Wilhelm. *Kartenmacher aller Länder und Zeiten.*
Stuttgart, Hiersemann, 1966. 243p.

568. Muller, Frederik, firm. *Remarkable maps of the xvth, xvith and*
xviith centuries reproduced in their original size. Amsterdam, 1894-97.
6 vols in 1.

569. Nordenskiöld, Nils A. E. friherne. *Facsimile atlas to the early*
history of cartography, with reproductions of the most important maps
printed in the xv and xvi centuries. Tr. from the Swedish original by
Johan A. Ekelöf and Clements R. Markham. Stockholm, 1889. N.Y., Kraus
Reprint Corp., 1961.

> "... this English edition was undertaken and sent to press during
> the printing of the Swedish original which was finished in March
> 1889." (Preface)

570. Polska Akademia Nauk. Instytut Geografii. *National and regional*
atlases; sources, bibliography, articles. Prepared by Jolanta Drecka,
Halina Tuszyńska-Rekawek under the direction of Stanislaw Leszezycki,
2d ed. Warsaw, 1964. 155p.

571. Ristow, Walter W. *Guide to the history of cartography; an annotated*
list of references on the history of maps and map-making. Wash., Library
of Congress, 1973. 96p.

572. Vatican. Biblioteca Vaticana. *Monumenta cartographica. Vaticana*
iussu Pii xii P.M.. Citta del Vaticana, 1944-55. 4 vols.

> A collection of reproductions depicting the history of cartography
> from the 14th to the 17th century.

573. Wieder, Frederik C. *Monumenta cartographica; reproductions of*
unique and rare maps, plans, views.... The Hague, Nijhoff, 1925-33.
5 vols.

Lettering and Typography

574. Bartz, Barbara S. "An analysis of the typographical legibility
literature; assessment of its applicability to cartography."
Cartographic journal 7:10-16, June 1970.

575. Bartz, Barbara S. "Type variation and the problem of cartographic type legibility." Ph.D. dissertation, Univ. of Wisconsin, 1969.

576. _____ . "Type variation and the problem of cartographic type legibility." Journal of typographic research 3:127-44, Apr. 1969; 3:387-98, Oct. 1969.

577. Crocker, W. T. "Type for maps." Cartography 5:95-100. 1964.

578. Gardiner, R. A. "Typographic requirements of cartography; a preliminary note." Cartographic journal 1:42-44, June 1964.

579. Hirsch, Steven A. "Automated name placement on maps." Master's thesis, State Univ. of New York, Buffalo, 1980.

580. Hoffmann-Feer, Eduard. Die Typographie im Dienst der Landkarte. Basel, Helbing & Lichtenhahn, 1969. 56p. illus.

581. Keates, J. S. "Lettering." (In Cartographic design and production. N.Y., Wiley, 1973. p.201-11)

582. McMurtrie, Douglas C. Printing geographic maps with movable types. N.Y., 1926. 16p.

583. "Map design and typography." Monotype recorder 43, no.1:42-52, summer 1964.

584. Riddiford, Charles E. "On the lettering of maps." Professional geographer 4:7-10, Sept. 1952.

585. Robinson, Arthur H. and Sale, Randall D. "Cartographic typography and lettering." (In Elements of cartography. 3d ed. N.Y., Wiley, 1969. p.273-92)

586. Saito, George K. "An investigation of some visual problems of cartographic lettering." Master's thesis, Univ. of Washington, 1962.

587. Taylor, Joseph C. "The use of typography in map making." Surveying and mapping (Wash., D.C.) 6, no.2:130-32. 1946.

588. Withycombe, J. G. "Lettering on maps." Geographical journal 73:429-46, May 1929.

Map Decoration

589. Bellaire, Alfred. Decorative initial letters used in atlases. London, Map Collectors' Circle, 1969. 7p. and 40 plates. (Map collectors' series 52)

590. Lynam, Edward. "The development of symbols, lettering, ornament, and colour on English maps." Procs of the British Records Association no.4:20-34. 1939.

591. Skelton, Raleigh A. "Colour in mapmaking." Geographical magazine
32:544-53, Apr. 1960.

592. _____. "Decoration and design in maps before 1700." Graphis
7:400-13. 1951.

593. _____. Decorative printed maps of the 15th to 18th centuries.
London, Staples Press, 1952. 80p. 84 plates.

A revised edition of Old decorative maps and charts by A. L.
Humphreys.

Map Reproduction

594. Adams, J. M. "Typeset maps." Penrose annual 65:190-202. 1972.

595. Baldock, E. D. Manual of map reproduction techniques. Ottawa,
R. Duhamel, 1965. 32p.

596. Boczar, Stanislaw. Kartografia; opracowanie map i reprodukeja
kartograficzna. Cracow, 1977. 101p.

597. Bramhall, C. W. "Photomechanical processes used in map reproduc-
tion." Cartographic journal 14:12-13, June 1977.

598. Clare, W. G. "Map reproduction." Cartographic journal 1:42-48,
Dec. 1964.

599. Gohm, Douglas C. Maps and prints for pleasure and investment.
N.Y., Arco, 1969. 197p.

600. Greggor, K. N. "Computer-aided map compilation." Cartography
9:24-34, Jan. 1975.

601. Harris, Elizabeth M. "Miscellaneous map printing processes in the
nineteenth century." (In Woodward, David, ed. Five centuries of map
printing. Chicago, Univ. of Chicago Press, 1975. p.113-37)

602. Koeman, C. "The application of photography to map printing and
the transition to offset lithography." (In Woodward, David, ed.
Five centuries of map printing. Chicago, Univ. of Chicago, 1975.
p.137-56)

603. Margerison, T. A. "Computer-aided map-making." Endeavour 1,
no.3/4:139-42. 1977.

604. Ovington, J. J. "An outline of map reproduction." Cartography
4:150-55, Sept. 1962.

605. Ristow, Walter W. "Lithography and maps 1796-1850." (In Woodward,
David, ed. Five centuries of map printing. Chicago, Univ. of Chicago
Press, 1975. p.77-112)

606. Robinson, Arthur H. and Sale, Randall D. "Map reproduction." (In
Elements of cartography. 3d ed. N.Y., Wiley, 1969. p.293-310)

607. Taylor, David R., ed. The computer in contemporary cartography.
Chichester, Wiley, 1980. 252p.

608. U.S. Dept. of the Army. Offset photolithography and map reproduc-
tion. Wash., D.C., 1970. nonconsecutive pagination.

609. Verner, Coolie. "Copperplate printing." (In Woodward, David, ed.
Five centuries of map printing. Chicago, Univ. of Chicago Press, 1975.
p.51-76)

610. Woodward, David. Cerographia; an enquiry into the technique and
history of the wax-engraving arts. Long Island, N.Y., Juniper Press,
1968. 24p.

History

611. Akademie für Raumforschung und Landesplanung. Zur Methodik von
Wirtschaftskarten des 19. Jahrhunderts. Hannover, Gebr. Jänecke, 1969.
83p.

612. Bagrow, Leo. History of cartography. rev. and enl. by R. A.
Skelton. Cambridge, Harvard Univ. Press, 1964. 312p. illus. plates.

613. Baltimore. Museum of Art. The world encompassed; an exhibition
of maps.... Baltimore, Trustees of the Walters Art Gallery, 1952. 125p.
60 plates.

614. Baynton-Williams, R. "The first printed maps." (In Investing in
maps. N.Y., C. N. Potter, 1969. p.20-39)

615. Bonnerot, G. "Cartographie." Encyclopaedia universalis 3:1000-
09. 1969.

616. Bricker, Charles. Landmarks of mapmaking; an illustrated survey
of maps and mapmakers. Maps chosen and displayed by R. V. Tooley.
Oxford, Phaidon, 1976. 276p. illus.

617. Grenacher, Franz. "The woodcut map." Imago mundi 24:31-41. 1970.

618. Imhof, Eduard. Kartographische Geländedarstellung. Berlin,
De Gruyter, 1965. 425p. illus.

619. McMurtrie, Douglas C. Printing geographic maps with movable types.
N.Y., 1925. 16p. illus.

620. Map collectors' series, vol. 1, 1963/64- London, Map Collectors'
Circle, 1964-

 The Series has reproduced maps for a number of countries beginning
 with vol. 1 (1963-64).

621. Peucker, Karl. "Zur Kartographischen Darstellung der dritten Dimension." Geographische Zeitschrift 7:22-41. 1901.

622. Robinson, Arthur H. "Mapmaking and map printing: the evolution of a working relation." (In Woodward, David, ed. Five centuries of map printing. Chicago, Univ. of Chicago Press, 1975. p.1-24)

623. Roger, Joseph. Die Geländedarstellung auf Karten. Munich, Riedel, 1908. 126p.

 On development of hachuring and contour lines.

624. Skelton, Raleigh A. "Early atlases." Geographical magazine 32:529-43, Apr. 1960.

625. Tooley, Ronald V. Maps and mapmakers. 6th ed. N.Y., Crown, 1978. 140p. illus. plates. facs

626. _____. Title pages from the 16th to 19th century. London, Map Collectors' Circle, 1975. 80 plates. (Map collectors' series 107)

627. Wilford, John N. The mapmakers. N.Y., Knopf, 1981. 414p. illus.

628. Woodward, David. "The woodcut technique." (In Five centuries of map printing. Chicago, Univ. of Chicago Press, 1975. p.25-50)

629. _____, ed. Five centuries of map printing. Chicago, Univ. of Chicago Press, 1975. 177p. plates.

Individual Countries

FRANCE

630. France. Armée. Service Géographique. La carte de France 1750-1898. Etude historique par le colonel Berthaut. Paris, 1898-99. 2 vols. illus. plates.

631. Pedley, Mary S. "The map trade in Paris 1650-1825." Imago mundi 33:33-45. 1981.

GREAT BRITAIN

Reference Work

632. Shirley, R. W. Early printed maps of the British Isles 1477-1650: a bibliography. London, Map Collectors' Circle, 1973-74. (Map Collectors' Circle. Map collectors series 90, 94-95, 97, 101)

History

633. Campbell, Tony. Catalogue 6 maps; outline of the British Isles: printed maps 1482-1887. London, R. Stockwell, 1970. 107p. 240 maps.

634. Glanville, Philippa. London in maps. London, The Connoisseur,
1972. 212p. illus.

635. Hyde, Ralph. Printed maps of Victorian London, 1851-1900.
Folkstone, Kent, Dawson, 1975. 271p. maps.

636. Royal Scottish Geographical Society. The early maps of Scotland.
3d ed. Rev. and enl. with A history of Scottish maps by D. G. Moir.
Edinburgh, 1973. 243p. maps.

637. Shearer, John E. Old maps and mapmakers of Scotland. Stirling,
R. S. Shearer, 1905. 86p. maps.

638. Thrower, Norman J., ed. The compleat plattmaker: essays on chart,
map, and globe making in England in the 17th and 18th centuries.
Los Angeles, Univ. of California Press, 1978. 241p. illus.

 Contains David Woodward's "English cartography 1650-1750,"
 p.159-93.

 ITALY

639. Almagia, Roberto. Monumenta Italiae cartographica. Florence,
Istituto Geografico Militare, 1929. 88p. maps.

640. Mazzetti, Ernesto. Cartografia generale del Mezzogiorno. Naples,
Edizioni Scientifiche Italiane, 1972. 2 vols. plates.

641. Traversi, Carlo. Storia della cartografia coloniale italiana.
Rome, Istituto Poligrafico della Siato, 1964. 294p. facs

 NETHERLANDS

Reference Work

642. Atlantes Neerlandici. Bibliography of terrestrial, maritime and
celestial atlases and pilot books, published in the Netherlands up to
1880. Comp. and ed. by Dr. I. C. Koeman. Amsterdam, Theatrum Orbis
Terrarum, 1967. 5 vols. facs

History

643. Baudet, Pierre J. Leven en werken van Willem Jansz. Blaeu.
Utrecht, Van der Post, 1871. 178p.

644. Denucé, Jean. De geschiedenis van de Vlaamsche Kaartsnijkunst.
Antwerp, De Nederlandsche Boekhandel, 1941. 96p. 18 plates. facs

645. _____ . Oud-Nederlandsche kaartmakers in betrekking met Plantijn.
Antwerp, De Nederlandsche Boekhandel, 1912-13. 2 vols. facs

646. Fockema Andreae, Sybrandus J. and Hoff, B. van 't. Geschiedenis der kartografie van Nederland, van den Romeinschen tijd tot het midden der 19de eeuw. 's-Gravenhage, Nijhoff, 1947. 127p. 25 plates (including maps)

647. Ghim, Walter. "Life of Mercator (or Vita Mercatoris) originally printed in the first Duisburg edition of Mercator's Atlas of 1595." (In Osley, Arthur S. Mercator. N.Y., Watson-Guptill, 1969. p.185-94)

648. Keuning, Johannus. "Sixteenth century cartography in the Netherlands." Imago mundi 9:35-63. 1952.

649. _____. Willem Jansz. Blaeu; a biography and history of his work as a cartographer and publisher. Rev. and ed. by Marijke Donkersloot-De Vrij. Amsterdam, Theatrum Orbis Terrarum, 1973. 164p. illus.

650. Koeman, Cornelis. Handleidung voor de studie van de topografische kaarten van Nederland 1750-1850. Groningen, Wolters, 1963. 120p. illus. facs

651. _____. Joan Bleau and his Grand atlas. London, Philip, 1970. 114p. illus.

About Joan Blaeu (1596-1673) and his Atlas major.

652. Mercator, Gerardus. Correspondance mercatorienne, publiée par Maurice van Durme. Antwerp, De Nederlandsche Boekhandel, 1959. 285p.

653. Osley, Arthur S. Mercator. A monograph on the lettering of maps, etc., in the 16th century Netherlands.... London, Faber and Faber, 1969. 209p. illus. facs

654. Raemdonck, Jean van. Gerard Mercator, sa vie et ses oeuvres. St. Nicolas, Dalschaert-Praet, 1869. 375p. illus.

655. Vrij, Y. Marijke de. The world on paper: cartography in Amsterdam in the 17th century. Amsterdam, Amsterdams Historisch Museum, 1967. 128p. illus.

SWITZERLAND

656. Blumer, Walter. Bibliographie der Gesamtkarten der Schweiz von Anfang bis 1802. Bern, 1957. 178p. illus. maps.

657. 500 Jahre schweizer Landkarten. Text by Georges Grosjean with the cooperation of Madlena Cavelti. Zurich, Füssli, 1971. 59p. illus. 30 maps.

658. Grob, Richard. Geschichte der schweizerischen Kartographie Bern, Kümmerly und Frey, 1941. 194p. maps.

UNITED STATES

659. Cumming, William P. The Southeast in early maps. Princeton,
Princeton Univ. Press, 1958. 275p. 67 maps.

660. Sanchez-Saavedra, E. M. A description of the country: Virginia's
cartographers and their maps. Richmond, Virginia State Library, 1975.
130p. illus.

661. Schwartz, Seymour and Ehrenberg, Ralph E. The mapping of America.
N.Y., Abrams, 1980. 363p. illus. maps.

662. Thompson, Morris M. Maps of America; cartographic products of the
United States Geological Society and others. Wash., Gov't Printing
Office, 1979. 265p. many maps.

663. Tooley, Ronald V. The mapping of America. London, Holland Press,
1980. 519p. 179 plates of maps.

664. Wheat, Carl Irving. Mapping the trans-Mississippi West 1540-1861.
San Francisco, Institute of Historical Geography, 1957-63. 5 vols. maps.

665. Winsor, Justin, ed. Narrative and critical history of America.
Boston, Houghton Mifflin, 1884-89. 8 vols. illus. maps.

666. Woodward, David. The all-American map; wax engraving and its
influence on cartography. Chicago, Univ. of Chicago Press, 1977. 168p.
illus.

667. _____. "Cerotyping and the rise of modern American commercial
cartography; a case study of the influence of printing technology on
cartographic style." Ph.D. dissertation, Univ. of Wisconsin, 1970. 265p.

OTHER COUNTRIES

668. Buczek, Karol. The history of Polish cartography from the 15th to
the 18th century. Translated by A. Potocki. Wroclaw, 1966. 1 portfolio
(135p. 61 maps)

669. Cortesão, Armando and Mota, Avelino T. de. Portugaliae monumenta
cartographica. Lisbon, 1960-62. illus. colored plates. maps.

670. Nicholson, N. L. and Sebert, L. M. The maps of Canada; a guide to
official Canadian maps, charts, atlases and gazetteers. Folkstone, Kent,
Dawson, 1981. 251p.

 Chapt. 16 is on map printing, methods, and map accuracies.

671. Tibbetts, Gerald R. Arabia in early maps. Naples, Falcon Press,
1978. 175p. maps.

 A bibliography of maps printed in Europe from the 15th century
 to 1751.

672. Tooley, Ronald A. Collectors' guide to maps of the African conti-
nent and southern Africa. London, Carta Press, 1969. 132p. and 100
plates of maps.

673. Yūsuf Kamal (Prince). Monumenta cartographica Africae et Aegypti.
Cairo, 1926-51. 5 vols. in 16. illus. plates. facs. maps.

6

MATHEMATICS

Reference Works

674. Karpinski, Louis. C. <u>Bibliography of mathematical works printed in America through 1850....</u> Ann Arbor, Univ. of Michigan Press, 1940. 697p. facs

675. Smith, David E. <u>Rara arithmetica; a catalogue of the arithmetics written before the year MDCI.</u> Boston, Ginn, 1908. 507p. illus. facs. Addenda, 1939. 52p.

676. Smith, Henry L. et al. <u>One hundred fifty years of arithmetic textbooks.</u> Bloomington, Bureau of Cooperative Research and Field Service, Indiana University, 1945. 153p. illus. facs (Indiana Univ. School of Education bulletin 21, no. 1)

Contains a list of 59 titles published between 1677 and 1937.

Manuals

677. Chaundy, Theodore W. et al. <u>The printing of mathematics; aids for authors and editors and rules for compositors and readers at the University Press, Oxford.</u> London, Oxford Univ. Press, 1954. 105p.

678. Phillipps, Arthur. <u>Setting mathematics: a guide to printers interested in the art.</u> Bristol, Monotype Corp/John Wright and Sons, 1956. 32p. (Monotype recorder, vol. 4, no. 4)

679. Swanson, Ellen. <u>Mathematics into type.</u> rev. ed. Providence, R.I., Mathematical Society, 1979. 90p.

680. William Byrd Press, Richmond. <u>Mathematics in type.</u> Richmond, 1954. 58p.

681. Wythe, W. <u>The mechanical composition of mathematics.</u> Oxford, Printed for the Monotype Corp. by Oxford Univ. Press, 1935. 11p.

History

682. Cajori, Florian. <u>The early mathematical sciences in North and South America.</u> Boston, Badger, 1928. 156p. illus. plates.

683. Karpinski, Louis C. The history of arithmetic. Chicago, Rand McNally, 1925. 200p. illus. facs

684. Richeson, A. W. "The first arithmetic printed in English." Isis 37:47-56, May 1947.

685. Wilson, Leslie. The history of the printing of scientific and mathematical texts; an exhibition of books at the Margaret Clapp Library of Wellesley College, Sept.-Nov. 1978. Wellesley, Mass., Wellesley College, 1978. 113p. illus.

MEDICINE

Reference Works

686. Crummer, Leroy. A catalogue, manuscripts and medical books printed before 1640 in the library of Leroy Crummer, Omaha, Nebraska. Omaha, 1927. 93p. plates.

687. Dawson, William and Sons, London. Medicine and science: a bibliographical catalogue of historical and rare books from the 15th to the 20th century. London, 1956. 610p. illus. (catalogue 91)

688. _____. Medicine, ancient and modern; a catalogue of rare books. London, 1968. 152p. illus.

689. Osler, William. Bibliotheca Osleriana; a catalogue of books illustrating the history of medicine and science, collected, arranged, and annotated by Sir William Osler and bequeathed to McGill University. Oxford, Clarendon Press, 1929. 785p.

 Reprinted with new prologue, addenda, and corrigenda in 1969.

690. Sallander, Hans. Bibliotheca Walleriana; the books illustrating the history of medicine and science collected by Dr. Eric Waller and bequeathed to the library of Royal University of Uppsala. Stockholm, Almqvist & Wiksell, 1955. 2 vols. 55 plates.

691. Wellcome Historical Medical Library. A catalogue of incunabula in the Wellcome Historical Medical Library by F. N. L. Poynter. London, Oxford Univ. Press, 1954. 160p. plates. facs

History

692. Ballard, James F. "Medieval manuscripts and early printed books illustrating the evolution of the medical book from 1250 to 1550." Bulletin of the Medical Library Association 23:173-88, Jan. 1935.

693. Blunt, Wilfrid. "The first printed herbals." (In The art of botanical illustration. 3d ed. London, Collins, 1955. p.31-44)

694. Chance, Burton. "Early printing of medical books and some of the printers who printed them." Bulletin of the history of medicine 22:647-63, Sept. 1948.

695. Hahn, André et al. Histoire de la médecine et du livre médical à la lumière des collections de la Bibliothèque de la Faculté de Médecine de Paris. Paris, Olivier Perrin, 1962. 430p.

696. Hargreaves, Geoffrey D. A catalogue of medical incunabula in Edinburgh libraries. Edinburgh, Royal Medical Society, 1976. 54p. illus.

697. Indiana University. Lilly Library. Medicine; an exhibition of books relating to medicine and surgery from the collection formed by J. K. Lilly. Bloomington, 1966? 100p. illus. facs

698. Iowa University. Health Sciences Library. Heirs of Hippocrates; the development of medicine in a catalogue of historic books in the Health Sciences Library, the University of Iowa. Iowa City, Friends of the Univ. of Iowa Libraries, 1980. 474p. illus. facs

699. Hough, John S. Incunabula medica. Trentonii, 1889. 86p. illus.

700. Keys, Thomas E. "The earliest medical books printed with movable type." Library quarterly 10:220–30, Apr. 1940.

701. Klebs, Arnold C. "Gleanings from incunabula of science and medicine." Papers of the Bibliographical Society of America 26:52–88. 1932.

702. _____ and Droz, E. Rémèdes contre la peste. Paris, 1925. 90p. facs

 Contains facsimiles, notes, and a list of incunabula on the plague.

703. Lindeboom, Gerrit A. Bibliographia Boerhaviana. Leyden, Brill, 1959. 105p. facs

704. McHenry, Lawrence C. Garrison's history of neurology. Rev. and enl. with a bibliography of classical, original, and standard works in neurology. Springfield, Thomas, 1969. 552p. illus. facs

705. Maggs Bros., London. Manuscripts and books on medicine, alchemy, astrology, and natural sciences. London, 1929. 618p. and index. facs (catalog 520)

706. Petit, Louis H. Essais de bibliographie médicale: conseils aux étudiants sur les recherches bibliographiques.... Paris, Masson, 1887. 249p.

707. Osler, William. Incunabula medica; a study of the earliest printed medical books, 1467–1480. London, printed for the Bibliographical Society at the Oxford University Press, 1923. 140p. 16 facs

708. Schullian, Dorothy M. "The cradle books of medicine." Journal of the American Medical Association 196:55–58, Apr. 4, 1966.

709. Sudhoff, Karl. Graphische und typographische Erstlinge der Syphilis-Literatur aus den Jahren 1495 und 1496. Munich, Kuhn, 1912. 27p. 24 plates.

710. Thornton, John L. Medical books, libraries and collectors....
2d ed. London, André Deutsch, 1966. 445p.

711. Walsh, M. N. "Medical printers of the Renaissance." Proceedings
of the Staff. Meetings of the Mayo Clinic 14:582-87. 1939.

Individual Countries

FRANCE

712. Cade, André. Les incunables médicaux lyonnais. Lyon, Impr. Rey,
1942. 44p. 10 plates.

713. Mornand, Pierre. "L'édition médicale en France depuis les origines
jusqu'à nos jours." Courrier graphique 20:29-47, Dec. 1938.

MEXICO

714. Guerra, Francisco. Bibliografía de la materia medica mexicana....
Mexico, Prensa Medica Mexicana, 1950. 423p. facs

715. _____. Iconografía médica mexicana; catálogo gráfico descriptiva
de los impresos mexicanos de 1552 a 1833.... Mexico, Impr. de Diario
Español, 1955. ccclxxviip. (chiefly facs)

716. Van Patten, Nathan. "Medical literature of Mexico and Central
America." Papers of the Bibliographical Society of America 24:150-99.
1930.

UNITED STATES

Reference Work

717. Guerra, Francisco. American medical bibliography 1639-1783; a
chronological catalogue, and critical and bibliographical study of books,
pamphlets, broadsides, and articles in periodical publications relating
to the medical sciences.... N.Y., Lathrop C. Harper, 1962. 885p. 187
facs (Yale Univ. Dept. of History of Science and Medicine. Publication
40)

General Works

718. Blake, John B. "Early American medical literature." Journal of
the American Medical Association 236:41-46, July 5, 1976.

719. Guerra, Francisco. "Medical almanacs of the American colonial
period." Journal of the history of medicine 16:234-55. 1961.

720. N.Y. Academy of Medicine. Catalogue of an exhibition of early and
later medical Americana. N.Y., Marchand, 1927. 64p. facs

OTHER COUNTRIES

721. Granjel, Luis S. El libro medico en España (1808–1936). Salamanca, 1975. 111p.

722. Lutzenkirchen, G. "La stampa medica in Italia nel xviii secolo." Medicina nei secoli 2:335–37, Sept./Dec. 1974.

723. Sudhoff, Karl. Deutsche medizinische Inkunabeln. Leipzig, Barth, 1908. 278p. 40 facs

8

MUSIC

Reference Works

724. Brussels. Bibliothèque Royale de Belgique. Catalogue des imprimés musicaux de xve, xvie, et xviie siècles, fonds généraux. By Bernard Huys. Brussels, 1965. 422p. facs Supplement 1974. 185p. illus.

Catalogue of 18th century published in 1974 (519p. illus.)

725. Davidsson, Åke. Bibliographie der musiktheoretischen Drucke des 16. Jahrhunderts. Baden Baden, 1962. 99p. 25 facs

726. _____. Bibliographie zur Geschichte des Musikdrucks. Uppsala, Almqvist & Wiksell, 1965. 86p.

727. Duckles, Vincent. "Histories and bibliographies of music printing and publishing." (In Music reference and research materials. 3d ed. N.Y., Free Press, 1974. p.386-406)

728. Kinkeldey, Otto. "Music and music printing in incunabula." Papers of the Bibliographical Society of America 26:89-118. 1932.

729. Krummel, Donald W. Guide for dating early published music; a manual of bibliographical practices. Hackensack, N.J., J. Boonin, 1974. 267p. illus. facs

730. Littleton, Alfred H. A catalogue of 100 works illustrating the history of music printing from the fifteenth to the end of the seventeenth century in the library of A. H. Littleton. London, 1911. 38p. illus.

731. Marco, Guy A. The earliest music printers of continental Europe; a checklist of facsimiles illustrating their work. Bibliographical Society of the Univ. of Virginia, 1962. 20p.

732. Meyer-Baer, Kathi. Liturgical music incunabula; a descriptive catalogue. London, Bibliographical Society, 1962. 63p. illus. facs

733. Uppsala. Universitet. Bibliotek. Catalogue critique et descriptif des imprimés de musique des xvie et xviie siècles. Uppsala, Almqvist & Wiksell, 1911-1951. 3 vols.

734. Walker, Arthur D. "Music printing and publishing: a bibliography." Library Association record 65:192-95, May 1963.

Manuals

735. Bachmann, J. H. Die Schule des Musiknoten-satzes. Ein praktischer Leitfaden zum Selbstunterricht. Leipzig, Waldow, 1865. 78 columns. illus.

736. Beaudoire, Théophile. Manuel de typographie musicale. Paris, 1891. 60p.

737. Eisenmenger, Michel. Traité sur l'art graphique et la mécanique appliqués à la musique. Paris, Gosselin, 1838. 182p.

738. Fournier, Pierre Simon. Les caractères de l'imprimerie. With four folding plates and 160 pages of specimen-types of characters, vignettes, music, etc. Paris, 1764.

739. _____. Manuel typographique. Paris, The Author, 1764-66. 2 vols. plates.

Contains four chapters on music printing.

740. _____. Traité historique et critique sur l'origine et les progrès des caractères de fonte pour l'impression de la musique, avec des épreuves de nouveaux caractères de musique, présentés aux imprimeurs de France. Berne, Chez Barbou, 1765. 47p.

741. Gamble, William. Music engraving and printing. London, Pitman, 1923. 266p.

742. Novello, Joseph A. Some account of the methods of musick printing, with specimens of the various sizes of moveable types. London ? 1847. pages ?

743. Talbot, H. S. and Co., Chicago. Guide to music publishing. Chicago, 1907. 30p.

General Works

744. Anthology of music. Ed. by K. G. Fellerer. Cologne, 1955-75. Index, 1976.

745. Austin, Ernest. The story of music printing. With an account of the firm of Lowe and Brydone. London, Lowe and Brydone, Printers, n.d. 31p. plates.

746. Darch, Bob. Music and paper. Toronto, Provincial Paper, 1962. 24p.

747. Deutsch, O. E. "Music bibliography and catalogues." Library 23:151-70, Mar. 1943.

748. Dona, Mariengela. "Stampa musicale." Enciclopedia della musica 4:273-74. 1964.

749. Foss, Hubert J. "Printing." Grove's dictionary of music and musicians. 5th ed. 6:928-34. 1954.

750. Gray, Norman. A note on music engraving and printing. London, Boosey & Hawkes, 1952. 12p.

751. Hader, Karl. Aus der Werkstaatt eines Notenstechers. Vienna, Waldheim-Eberle, 1948. 78p.

752. Iurgenson, Boris. Ocherk istorii notopechatania. Moscow, 1928. 188p.

753. King, Alexander H. Four hundred years of music printing. 2d ed. London, British Museum, 1968. 32p. plus 20 plates.

754. Kinsky, Georg et al., eds. A history of music in pictures. N.Y., Dutton, c1929. 263p.

755. Krummel, Donald W. "Musical functions and bibliographical forms." Library 4:327-50, Dec. 1976.

756. _____. "Printing and publishing of music: publishing." New Grove dictionary of music and musicians 15:260-74. 1980.

757. Kunin, Mikhail E. Iz istorii notopechatania. Moscow, 1963. 76p.

758. Lenneberg, Hans. "Dating engraved music; the present state of the art." Library quarterly 41:128-40, Apr. 1971.

759. Luther, W. and Schaal, R. "Notendruck." Musik in Geschichte und Gegenwart: Allgemeine Enzyklopädie der Musik 9:1667-95, 1961.

760. "Music composition." (In American dictionary of printing and book-making. Ed. by W. W. Pasko. Detroit, Gale Research, 1967c1894. p.383-87)

761. "Notendruck und -stich." Riemann Musik-Lexicon 3:638-41. 1967.

762. Oldman, C. B. "Musical first editions." (In Carter, John, ed. New paths in book collecting. London, Constable, 1934. p.93-124)

763. Poole, H. Edmund. "Printing and publishing of music: printing." New Grove dictionary of music and musicians 15:232-60. 1980.

764. Schaal, R. Musiktitel aus fünf Jahrhunderten; eine Dokumentation zur typographischen und künstlerischen Gestaltung und Entwicklung der Musikalien. Wilhelshaven, Heinrichshofen, 1972. 250p.

765. Sloboda, John. "The uses of space in music notation." Visible language 15:86-110. 1981.

766. Toledo, Museum of Art. The printed note; five hundred years of music printing and engraving. Toledo, 1957. 144p. illus. (exhibit catalog)

 New edition with corrections and a new preface issued in 1981 by Da Capo Press.

767. Volkmann, Ludwig. "Musikalische Bibliophilie." Zeitschrift für Bücherfreunde 1:21-26. 1909/1910.

768. Weale, William H. Historical music loan exhibition, Albert Hall, London, June-Oct. 1885; a descriptive catalogue of rare manuscripts and printed books, chiefly liturgical. London, Quaritch, 1886. 191p. illus.

769. Zur Westen, Walter von. Musiktitel aus vier Jahrhunderten; Festschrift anlässlich der 75 jährigen Bestehens der Firma C. G. Röder. Leipzig, 1921. 116p. 97 facs

Early History to the Twentieth Century

770. Audin, Marius. "Les origines de la typographie musicale." Bibliophile 1:142-48, 223-29; 2:13-19. 1931.

771. Clair, Colin. "The first music printers." (In A history of European printing. London, Academic Press, 1976. p.207-18)

772. Duggan, Mary K. Early music printing in the Music Library. Berkeley, General Library, Univ. of California, 1977. 32p. illus.

773. Flower, Desmond. "On music printing 1473-1701." Book collector's quarterly 1:76-92, Oct./Dec. 1931.

774. Fournier, Pierre Simon. Traité historique et critique sur l'origine et les progrès des caractères de fonte pour l'impression de la musique. Berne, 1765. 47p.

775. Gilson (F. H.) Company. Music-book printing with specimens. Boston, 1897. 32p.

776. Goebel, Theodor. "Von Lithographie und Steindruck: Der Musiknoten-druck." (In Graphischen Künste der Gegenwart. Stuttgart, Krais, 1895. p.130-36)

777. Heartz, Daniel. "Typography and format in early music printing." Music Library Association Notes 23:702-06, June 1967.

778. Hershberger, Mabel I. "History and development of the processes of music printing." M. A. thesis, Kent State, 1958. 344p.

779. Krummel, Donald W. "Oblong format in early music books." Library 26:312-24. 1971.

780. Meyer-Baer, Kathi. "Der Musikdruck in Inkunabeln; ein übersehnes Hilfsmittel zur Beschreibung." Libri 10:105-10. 1960.

781. _____ and O'Meara, Eva J. "The printing of music 1473-1934." Dolphin no.2:171-207. 1935.

782. Pattison, Bruce. "Notes on early music printing." Library 19:389-421, Mar. 1939.

783. Poole, H. Edmund. "New music types: invention in the eighteenth century." Journal of the Printing Historical Society 1:21-38. 1965. Also 2:23-44. 1966.

784. Riemann, Hugo. "Notenschrift und Notendruck; bibliographische-typographische Studie." (In Festschrift zur 50 jährigen Jubelfeier des Bestehens der firma Röder, Leipzig. Leipzig, C. G. Röder, 1896. 88p.)

 The book begins with writings on other subjects followed by
 Riemann's work of 88 pages.

785. Squire, William B. "Notes on early music printing." Bibliographica 3:99-122. 1897.

786. Thuerlings, Adolf. Der Musikdruck mit beweglichen Metaltypen im 16. Jahrhundert und die Musikdrucke des Mathias Apiarius in Strassburg und Bern. Leipzig, Breitkopf & Härtel, 1892. 32p.

787. Tiersot, J. "Les incunables de la musique." Bulletin du bibli-ophile 13:110-16. 1934.

Twentieth Century

788. Aird and Coghill, Ltd. Specimens of music engraving and printing. Glasgow, 1932. 26p.

789. Brewer, Roy. "Music and print." Penrose annual 64:144-52. 1971.

790. Foss, Hubert J. "The printing of music: some problems of today." Gutenberg Jahrbuch 1931, p.293-300.

791. Gomberg, David. "A computer-oriented system for music printing." Doctor of Science dissertation, Washington Univ., 1975. 126p.

Individual Countries

BELGIUM

792. Bergmans, Paul. La typographie musicale en Belgique au xvie siècle. Brussels, Editions du Musée du Livre, 1930. 33p.

 Reprint from Histoire du livre et de l'imprimerie en Belgique.
 Brussels, 1929. pt.5, p.47-75.

793. Rosart, Jacques F. The type specimen of Jacques-François Rosart, Brussels 1768; a facsimile. Amsterdam, Van Gent, 1973. 77p. and facsimile.

 Introduction and notes by Fernand Baudin and Netty Hoeflake.

794. Stellfeld, Jean A. Bibliographie des éditions musicales plan-tiniennes. Brussels, Palais des Academies, 1947. 248p. 21 facs

CANADA

795. Calderisi, Maria. Music printing in the Canadas 1800-1869. Ottawa, National Library of Canada, 1981. 128, 124p. illus.

796. Kallman, Helmut. "Canadian music publishing." Papers of the Bibliographical Society of America 13:40-48. 1974.

797. _____. "Publishing." (In Encyclopedia of music in Canada. Ed. by Helmut Kallman and others. Toronto, Univ. of Toronto Press, 1981. p.782-83)

DENMARK

798. Davidsson, Åke. Dansk musiktryck intill 1700-talets mitt. Uppsala, Almqvist & Wiksell, 1962. 100p.

799. Fog, Dan. Dänische Musikverlag und Notendruckverein. Beiträge zur Musikaliendatierung. Copenhagen, The Author, 1972. 27p.

FRANCE

Reference Works

800. Hopkinson, Cecil. A dictionary of Parisian music publishers, 1700-1950. London, 1954. 131p. 3 facs

Reprinted with a new preface by Jacques Barzun by Plenum in N.Y. in 1979.

801. Kolb, Albert. "Musikdruck." (In Bibliographie des französischen Buches im 16. Jahrhundert. Wiesbaden, Harrassowitz, 1966. p.202-13)

General Works

802. Dalbanne, C. "Robert Granjon, imprimeur de musique." Gutenberg Jahrbuch 1939, p.226-32.

803. Desgraves, Louis. Les Haultin, 1571-1623. Geneva, Droz, 1960. 168p. illus.

804. Goovaerts, Alphonse. Notice biographique et bibliographique sur Pierre Phalèse, imprimeur de musique à Anvers au xvi⁻siècle. Brussels, Toint-Scohier, 1869. 82p. (Extrait du Bibliophile belge, vol. 3)

805. Heartz, Daniel. Pierre Attaingnant, royal printer of music; a historical study and bibliographical catalogue. Berkeley, Univ. of California Press, 1969. 451p. illus. plates. facs

806. Pogue, Samuel F. Jacques Moderne: Lyons music printer of the sixteenth century. Geneva, Droz, 1969. 412p. illus. facs

807. Young, William. "Music printing in sixteenth century Strasbourg." Renaissance quarterly 24:486-501, winter 1971.

 GERMANY

808. Audin, Marius. "Gottlob Breitkopf et la typographie musicale." Gutenberg Jahrbuch 1950, p.245-54.

809. Berz, Ernst-Ludwig. Die Notendrucker und ihre Verleger in Frankfurt a.m. von den Anfängen bis etwa 1630. Kassel, Bärenreiter, 1970. 336p. (Catalogue musicus 5)

810. Bridgman, Nanie. "Christian Egenolff, imprimeur de musique." Annales musicologiques 3:77-177. 1955.

811. Gericke, Hannelore. Der Wiener Musikalienhandel von 1700 bis 1778. Graz, Bohlaus Nachf., 1960. 150p.

812. Grotefend, Hermann. Christian Egenolff, der erste ständige Buchdrucker zu Frankfurt a.m. und seine Vorlaufer. Frankfurt, 1881. 28p. 2 plates.

813. Hase, Oskar von. Breitkopf und Härtel, Buch- und Notendrucker, Buch- und Musikalienhandler in Leipzig. Leipzig, 1894. 46p. illus. plates.

814. _____. Breitkopf & Härtel; Gedenkscrift und Arbeitsbericht. 4th ed. Leipzig, Breitkopf & Härtel, 1917-19. 2 vols. illus. facs

815. Kraneis, Oskar. "Die Musikalienhandel in Frankfurt a.m. von seinen Anfängen bis zum Jahr 1700." Thesis, Univ. of Frankfurt, 1974. 245p. facs

816. Layer, Adolf. "Notendrucker und Musikverlager in Bayern; ein Rückblick auf fünf Jahrhundete." Gutenberg Jahrbuch 1973, p. 329-36.

817. Lipphardt, Walther. Gesangbuchdrucke in Frankfurt a.m. vor 1569. Frankfurt, Kramer, 1974. 226p. illus. plates.

818. Molitor, Raphael. Deutsche Choral-Wiegendrucke; ein Beitrag zur Geschichte des Chorals und des Notendruckes in Deutschland. Regensburg, Pustet, 1904. 77p. illus. plates. facs

819. Müller, Hans Christian. "Die Liederdrucke Christian Egenolffs." Dissertation, Univ. of Kiel, 1964. 278p.

820. Wohnhaas, Theodor. "Nürnberger Gesangbuchdrucker und Verleger im 17. Jahrhundert." (In Ruhnke, Martin, ed. Festschrift Bruno Stäblein. Kassel, Bärenreiter, 1967. (p.301-15)

821. Wohnhaas, Theodor. "Zum Nürnberger Musikdruck und Musikverlag im 16. und 17. Jahrhundert." Gutenberg Jahrbuch 1973, p.337-43.

822. Zirnbauer, Heinz. Geistliche Musik des Mittelalters und der Renaissance. Handschriften und frühe Drucke in Nürnberger Bibliotheken. Nuremberg, Staatsbibliothek Nürnberg, 1963. pages? plates. (exhibit catalog)

GREAT BRITAIN

Reference Works

823. Humphries, Charles. Music publishing in the British Isles, from the earliest times to the middle of the nineteenth century; a dictionary of engravers, printers, publishers, and music sellers, with a historical introduction by Charles Humphries and William C. Smith. London, Cassell, 1954. 354p. 2d ed. with supplement. 1970. 392p. plates. facs

824. Kidson, Frank. British music publishers, printers and engravers ... from Queen Elizabeth's reign to George IV, with select bibliographical lists of musical works printed and published within that period. London, W. E. Hill, 1900. 231p.

825. Steele, Robert. The earliest music printing; a description and bibliography of English printed music to the close of the sixteenth century. London, Printed for the Bibliographical Society, 1903. 102p. facs

 Reprinted, London, 1965, with an appendix of addenda and corrigenda.

Early History to the Present

826. Dix, Ernest R. "Some Dublin music printers and music sellers of the eighteenth century." Irish book lover 18, no.1:26-28, Jan/Feb. 1930.

827. Flood, W. H. "Dublin music printing from 1685 to 1750." Bibliographical Society of Ireland. Publications 2, no.1:7-12, 1921.

828. _____. "Dublin music printing from 1750 to 1790." Bibliographical Society of Ireland. Publications 2, no.5:101-06. 1923.

829. _____. "John and William Neale, music printers, 1721-1741." Bibliographical Society of Ireland. Publications 3, no.8:85-89. 1928.

830. _____. "Music printing in Dublin from 1700 to 1750." Royal Society of Antiquaries of Ireland. Journal ser. 5, 18, pt.3:236-40. 1908.

831. Foss, Hubert J. "Modern styles in music printing in England." Fleuron no.3:89-106. 1924.

832. Harding, Walter N. "British song books and kindred subjects."
Book collector 11, no.4:448-59. 1962.

833. King, A. Hyatt. "The significance of John Rastell in early music
printing." Library 26:197-214, Sept. 1971.

 King credits Rastell with having produced the earliest broadside
 with music printed anywhere in Europe and the earliest mensural
 music printed in England.

834. Krummel, Donald W. English music printing 1553-1700. London,
Bibliographical Society, 1975. 188p. illus. facs

835. Maas, William. "Some eighteenth century song books." Imprint
1:327-44, May 1913.

836. Miller, M. H. "London music printing c.1641-c.1700." M. A. thesis,
Univ. College, London, 1971.

837. Murrie, Eleanore B. "Notes on the printers and publishers of
English song-books 1651-1702." Edinburgh Bibliographical Society.
Transactions 1, pt. 3:243-76. 1938.

838. Poole, H. Edmund. "A day at a music publishers; a description of
the establishment of D'Almaine & Co. reprinted with an introduction,
notes, and commentary by H. Edmund Poole." Journal of the Printing
Historical Society no.14:59-81. 1979/80.

 D'Almaine and Co. was a firm of musical instrument makers, music
 sellers, and publishers in London for more than 80 years beginning
 in 1785.

839. Stainer, John, ed. Early Bodleian music; sacred and secular songs,
together with other manuscript compositions in the Bodleian Library,
Oxford ... N.Y., H. W. Gray, 1913. 2 vols. facs

ITALY

Reference Work

840. Sartori, Claudio. Dizionario degli editori musicali italiani
(tipografi, incisori, librai-editori). Florence, Olschki, 1958. 215p.
plates.

General Works

841. Bridgman, Nanie. "La typographie musicale italienne (1475-1630)
dans les collections de la Bibliothèque Nationale de Paris." (In Heckmann,
Harald and Rehm, Wolfgang, eds. Mélanges offerts à Vladimir Federov....
Kassel, Bärenreiter, 1966. p.24-27)

842. Chapman, Catherine W. "Andrea Antico." Ph.D. dissertation,
Harvard Univ., 1964.

843. Cusick, Suzanne G. Valerio Dorico; music printer in sixteenth-century Rome. Ann Arbor, Mich., UMI Research Press, 1981. 315p. illus.

A revision of the author's thesis (Ph.D., Univ. of North Carolina, 1975)

844. Dona, Mariangela. La stampa musicale a Milano fino all'anno 1700. Florence, Olschki, 1961. 167p. facs

845. Duggan, Mary K. "Italian music incunabula: printers and type-fonts." Ph.D. dissertation, Univ. of California, Berkeley, 1981. 540p.

846. Vernarecci, Augusto. Ottaviano de' Petrucci da Fossombrone, inventore dei tipi mobili metallici fusi della musica nel secolo xv. 2d ed. Bologna, Romagnoli, 1882. 288p.

NETHERLANDS

Reference Work

847. Goovaerts, Alphonse J. Histoire et bibliographie de la typographie musicale dans les Pays-Bas. Anvers, Koch , 1880. 608p.

General Works

848. Bain, S. E. "Music printing in the Low Countries in the sixteenth century." Ph.D. dissertation, Girton, Cambridge University, 1974. 200p.

849. Rasch, Rudi A. "Musica dîs curae est: the life and works of Amsterdam music printer Paulus Matthysz (1613/14-1684)." Quaerendo 4:86-99. 1974.

850. _____. "Noord-Nederlandse Muziekuitgeven met de Plantijnse Notentypen." Gulden Passer 51:9-18. 1973.

850a. Vervliet, Hendrik D. L. "Music." (In Sixteenth-century printing types of the Low Countries. Amsterdam, Hertzberger, 1968. p.321-47)

RUSSIA

851. Ivanov, Georgii K. Notoizdatelskoe delo v Rosii. Moscow, 1970. 63p.

852. Vol'man, Boris L. Russki notnye izdaniia xix--nachala xx veka. Leningrad, 1970. 216p.

The author covered the 18th century in a book published in 1957.

SPAIN

853. Riaño, Juan F. Critical and bibliographical notes on early Spanish music. London, Quaritch, 1887. 154p. many facsimile plates.

854. Romero de Lecea, Carlos. Introduccion a los viejos libros de musica. Madrid, Joyas Bibliograficas, 1976. 138p. facs

UNITED STATES

(Excludes sheet music)

855. Daniel, Ralph T. The anthem in New England before 1800. Evanston, Northwestern Univ. Press, 1966. 282p. facs

856. Krummel, Donald W. "Philadelphia music engraving and publishing, 1800-1820." Ph.D., Univ. of Michigan, 1958. 2 vols. (394 leaves). illus.

857. Metcalf, Frank J. American writers and compilers of sacred music. N.Y., Abingdon Press, 1925. 373p. facs

858. New York Public Library. Music Division. Music printing in America; an exhibition of printing methods, 1698-1950. N.Y., 1950.

Film reproduction of exhibits (specimen pages, portraits, proof-sheets, etc.)

859. Thorson, Theodore W. "A history of music publishing in Chicago 1850-1960." Ph.D., Northwestern Univ., 1961. 339 leaves.

860. White, Josephine C. "Music printing and publishing in Philadelphia, 1761-1840; a technical and sociological study." Master's thesis, Columbia Univ., 1949. 248p.

861. Wolfe, Richard J. Early American music engraving and printing; a history of music publishing in America from 1787 to 1825 with commentary on earlier and later practices. Urbana, Univ. of Illinois Press, 1980. 321p. illus. plates.

OTHER COUNTRIES

862. Davidsson, Åke. "Studier rörande svensk musiktryck före ar 1750." Thesis, Univ. of Uppsala, 1957. 167p.

863. Przywecka-Samecka, Maria. Drukarstwo muzyczne w Polske do końca xviii wieku. Cracow, 1969. 263p. illus. facs

RELIGION

Reference Works

864. Adomeit, Elizabeth E. Three centuries of thumb Bibles: a check-list. N.Y., Garland, 1980. 390p. illus. facs

 A bibliography of 296 editions printed between 1601 and 1890. A thumb Bible is a small volume, about two inches or less in size, written for children.

865. Copinger, Walter A. Incunabula Biblica, or, the first half century of the Latin Bible. Being a bibliographical account of the various editions. London, Quaritch, 1892. 226p. plates.

866. Lenhart, John M. "Ecclesiastical printers: priests, clerics, religious 1455-1520." (In Introduction to checklists of names of places where typography was applied, of master printers, workmen, publishers, promoters, etc. St. Louis, Central Bureau, Catholic Central Union, 1959)

867. North, Eric M. The book of a thousand tongues; being some account of the translation and publication of all or part of the Holy Scriptures into more than a thousand languages and dialects with over 1100 examples from the text. N.Y., Published for the American Bible Society by Harper, 1938. illus. facs

868. Rosenkilde, Volmer. Europaeiske bibeltryck. Esbjerg, K. Rosendals, 1952. 236p. facs

869. "Notable editions of the Bible." (In Antiquarian Bookman. Bookman's yearbook 1956, p.406-14)

870. Rumball-Petre, Edwin A. Rare Bibles; an introduction for collectors and a descriptive checklist. 2d ed. N.Y., Duschnes, 1954. 53p. facs

History

871. Alès, Anatole. "Les moines imprimeurs." Bulletin du bibliophile 1872. p.405-12.

 The Benedictines in Europe in the 16th century.

872. Auer, Wilhelm. Katholische Bibelkunde. Stuttgart, Verlag Katholisches Bibel-Werk, 1956. 176p. 30 plates. facs

873. Berkowitz, David S. In remembrance of creation; evolution of art
and scholarship in the medieval and renaissance Bible. Waltham,
Brandeis Univ. Press, 1968. 141p. plates. facs

> Covers manuscripts, incunabula, 16th century scholarly editions,
> 16th and 17th century translations. Contains a great many
> facsimiles. Appendix includes an index to printers and publishers.
> Notes for the entries in the bibliography are excellent.

874. Bern. Schweizerisches Gutenbergmuseum. Die Buchdruckerkunst im
Dienst der Kirche. Bern, Schweizerische Gutenbergstube, 1918. 64p.
illus. facs

875. Biblia pauperum, nach dem einzigen exemplare in 50 Darstellung.
Ed. by Paul Heitz. Strasbourg, J. H. E. Heitz, 1903. 45p. illus.
50 plates.

> Wilhelm L. Schreiber wrote the introductory essay about the
> origin and development of the Biblia pauperum.

876. Black, M. H. "The evolution of a book-form: the octavo Bible
from manuscript to the Geneva version." Library 16:15-28, Mar. 1961.

877. _____. "The evolution of a book form: II. The folio Bible to
1560." Library 18:191-203, Sept. 1963.

878. _____. "The printed Bible." (In the Cambridge history of the
Bible. Cambridge, Univ. Press, 1963. vol. 3, p. 408-75)

879. Bohatta, Hanns. Liturgische Drucke und liturgische Drucker.
Regensburg, F. Pustet, 1926. 75p. 26 plates. facs

880. Cornell, Henrik. Biblia pauperum. Stockholm, Thule-tryck, 1925.
372p.

881. Danzer, Beda. "Die Buchdruckerein des Benediktinerordens."
Zentralblatt für Bibliothekswesen 51:606-15, Dec. 1934.

882. Fluri, A. "Die Buchdruckerkunst im Dienst der Kirche."
Gutenbergstube 3:93-99. 1917. Also 4:49-88. 1918.

883. Goeze, Johann M. Versuch einer Historie der gedruckten nieder-
sächsischen Bibeln vom Jahre 1470 bis 1621. Halle, Bey J. J. Gebauers
witwe, 1775. 412p.

884. Harrison, John C. "Bible (printed editions)." Encyclopedia of
library and information science 2:358-67. 1969.

885. _____. Five hundred years of the printed Bible; an address
delivered on Dec. 6, 1962 in the Hunt Botanical Library, Pittsburg.
Pittsburgh, Pittsburgh Bibliophiles, 1964. 24p. facs

886. Herscher, Irenaeus (Rev.). "Franciscans and the art of printing."
Catholic library world 11:203-10, Apr. 1940.

887. Kingdon, Robert M. "Patronage, piety, and printing in sixteenth century Europe." (In Pinkney, David H. and Ropp, Theodore, eds. A festschrift for Frederick B. Artz. Durham, Duke Univ., 1964. p.19-36)

888. Lenhart, John M. (Rev.). "Franciscan printing houses in pre-Reformation times." Franciscan studies 7:91-97, Mar. 1947.

889. _____. Pre-Reformation printed books; a study in statistical and applied bibliography. N.Y., J. F. Wagner, 1935. 197p. (Franciscan studies no. 14)

890. Loftie, William J. A century of Bibles: or the authorized version from 1611 to 1711 ... with lists of Bibles in the British Museum, Bodleian, Stuttgart, and other libraries. London, B. M. Pickering, 1872. 249p. illus.

891. Lüthi, Karl J. Über die Bibelsammlung in der Schweizerischen Landesbibliothek in Bern. Bern, Büchler, 1953. 37p. illus.

892. Metzger, Bruce M. "Three learned printers and their unsung contribution to biblical scholarship." Journal of religion 32:254-62, Oct. 1952.

 On William Bowyer, Isaiah Thomas, and Robert Young (1822-1888)

893. Oakes, Suzanne M. "Monastic printing presses past and present." M.A. thesis, Univ. of Sheffield, 1974.

894. Oxford University. Bodleian Library. Latin liturgical manuscripts and printed books. Oxford, 1952. 61p. 20 facs (exhibit catalog)

895. Ringwald, Alfred. Das ewige Wort. Die Bibel, ihre Handschriften, Drucke und Übersetzung von den Anfängen bis zur Gegenwatt. Stuttgart, Privileg Württ Bibelanst, 1955. 35p.

896. Robert de Bourbon, Duke of Parma. Livres de liturgie imprimés aux xve et xvie siècles faisant partie de la bibliothèque de son altesse royale Le duc Robert de Parme. Paris, Giraud-Badin, 1932. 162p. illus. plates.

897. Shanahan, Thomas J. "Monastic printing presses in the fifteenth century." Catholic library world 12:72-78, Dec. 1940.

898. Sotheby, Samuel L. Principia typographica. London, 1858. 3 vols. 120 plates.

899. University of Dayton. Marian Library. The book of books; the word of God among the people of God; an exhibit of Biblical literature. Dayton, Ohio, 1973. 21p.

900. Updike, Daniel B. "Some notes on liturgical printing." Dolphin no.2:208-19. 1935.

901. Williamson, George C. "The books of the Carthusians." Bibliographica 3:212-31. 1897.

Individual Countries

BELGIUM

902. De Clerq, Carlo. Les éditions bibliques, liturgiques et canoniques de Plantin." Gulden passer 34:157-92. 1956.

903. Kingdon, Robert M. "The Plantin breviaries: a case study in the sixteenth century business operations of a publishing house." Bibliothèque d'humanisme et Renaissance 22:133-50. 1960.

904. Voet, Léon. "De Antwerpse Polyglot-bijbel." Noordgouw 13:33-52. 1973.

FRANCE

905. Chèvre, Marie. "La typographie du xvi ͬ siècle au service de la pensée religieuse." Gutenberg Jahrbuch 1965, p.271-78.

906. Choux, Jacques. "Les rituels imprimés du diocèse de Toul. Notice bibliographique." Gutenberg Jahrbuch 1965, p.99-109.

907. Labande, L. H. "Les premiers livres liturgiques imprimés des églises provençales." Gutenberg Jahrbuch 1931, p.166-200.

908. Sayce, R. A. "The Huguenot Bible." Procs of the Huguenot Society of London 22, no.3:224-34. 1973.

GERMANY

909. Barwick, George F. "The Lutheran press at Wittenberg." Bibliographical Society, London. Trans. 3:9-25. 1895/96.

910. Corsten, Severin. "Eine Klosterdruckerei in der Kölner Kartause." (In Essays in honor of Victor Scholderer. Ed. by D. E. Rhodes. Mainz, Pressler, 1970. p.337-48)

911. Falk, Franz. Die Druckkunst im Dienst der Kirche, zunächst in Deutschland bis zum Jahre 1520. Amsterdam, Rodopi, 1879. 108p.

912. Ising, Gerhard, ed. Die niederdeutschen Bibelfrühdrucke. Berlin, Akademie Verlag, 1961-76. 6 vols.

913. Masson, (Sir) Irvine. The Mainz psalters and Canon missae 1457-1459. London, Printed for the Bibliographical Society, 1954. 72p. illus. facs

914. Scheide, William H. "A speculation concerning Gutenberg's early plans for his Bible." Gutenberg Jahrbuch 1973, p.129-39.

915. Sotheby, Samuel L. Principia typographica. London, Printed for the Author by Walter McDowall, 1858. 3 vols. 120 plates.

Vol 2 is on block books of scriptural history issued in Germany.

916. Stummvoll, Josef. "Die Gutenberg-Bibel; eine Census-Übersicht und Konkordanz der wichtigsten Zählungen." Biblos 20:19-43. 1971.

917. Todd, William B. "The Gutenberg Bible; new evidence of the original printing." AB bookman's weekly, Dec. 20-27, 1982, p.4363, 4366-89.

918. Tronnier, Adolph. Die Missaldrucke Peter Schöffers und seines Sohnes Johann. Mainz, Verlag der Gutenberg-Gesellschaft, 1908. 28-220p. facs

919. Volz, Hans. Bibel und Bibeldruck in Deutschland im 15. und 16. Jahrhundert. Mainz, 1960. 78p.

920. Walther, Wilhelm. Die deutsche Bibelübersetzung des Mittelalters. Braunschweig, Wollermann, 1889-92. 766 columns. plates. facs

GREAT BRITAIN

921. Cambridge University Press. 300 years of printing the authorized version of the Holy Bible at Cambridge 1629-1929. Cambridge, 1929. 17, [3]p. plates.

922. Glaister, Geoffrey. "Bible printing in England." (In Glaister's Glossary of the book. 2d ed. Berkeley, Univ. of California Press, 1979. p.40-43)

923. Graham, Rigby. "Printing at Mount Saint Bernard Abbey." Private library 5:24-27, Apr. 1964.

924. Handover, P. M. "The Bible patent." (In Printing in London. Cambridge, Harvard Univ. Press, 1960. p.73-95)

925. Morison, Stanley. English prayer books; an introduction to the literature of Christian public worship. rev. ed. Cambridge, Univ. Press, 1943. 142p.

926. Mortimer, Russell S. "Biographical notices of printers and publishers of Friends books up to 1750...." Journal of documentation 3:107-25, Sept. 1947.

 A continuation to 1850 in Friends' Historical Society journal 50, no.3:100-33. 1963.

927. Rogers, Bruce. "Account of the making of the Oxford Lectern Bible, 1936." (In "The trade" passages from the printing craft, 1550-1935. Selected by Ellic Howe. London, Hutchinson, 1943. p.116-36)

928. Rostenberg, Leona. Literary, political, scientific, religious and legal publishing, printing, and bookselling in England 1551-1700: twelve studies. N.Y., Burt Franklin, 1965. 2 vols. facs

929. Stokes, Roy. "Printing of the great English Bible of 1539." American Theological Library Association. Summary of procs, 31st annual conference, June 20-24, 1977, p.108-19.

930. Vogel, Paul H. "Niederländische und englische Bibeldrucke des 15. und 16. Jahrhunderts." Libri 8, no.2:127-40. 1958.

931. Waite, Harold E. "Printing and circulating the Bible in Great Britain." Gutenberg Jahrbuch 1954, p.238-43.

932. Ward, Philip. "Stanbrook Abbey Press." Private library 4:13-15, Jan. 1962.

ITALY

933. Bellini, Giuseppe. Storia della tipografia del Seminario de Padova, Padova 1684-1938. Padua, Gregoriana Editrica, 1938. 453p. illus. facs

934. Carosi, Gabriele P. Subiaco e l'introduzione della stampa in Italia. Milan, Bramante, 1972. 75 [16]p. illus.

935. Rogers, David. "Johann Hamman at Venice; a survey of his career...." (In Essays in honor of Victor Scholderer. Ed. by D. E. Rhodes. Mainz, Pressler, 1970. p.337-48)

 Johann Hamman was a prolific printer of liturgical books.

MEXICO

936. Wright, John. "The Bible in Mexico." (In Early Bibles of America. 3d ed. N.Y., Whitaker, 1894. p.304-12)

937. Zulaica Garate, Román. Los Franciscanos y la imprenta en Mexico en el siglo xvi. Mexico, Robredo, 1939. 373p. illus. facs

NETHERLANDS

938. Löffler, Klemens. "Das Schrift und Buchwesen der Bruder vom gemeinsamen Leben." Zeitschrift für Bucherfreunde 11:286-93. 1907/1908.

939. Shepperd, L. A. "Printing at Deventer in the fifteenth century." Library 24:101-19, Dec. 1943/Mar. 1944.

940. Sotheby, Samuel L. Principia typographica. The block books or xylographic delineations of scripture history, issued in Holland, Flanders, and Germany during the fifteenth century.... London, Printed for the Author by Walter McDowall, 1858. 3 vols. 120 plates. facs

 Vol. 1 covers Holland and the Low Countries.

941. Verwey, Herman de la Fontaine. "De Nederlandse drukkers en de Bijbel." (In Drukkers, liefhebbers en piraten in de zeventiende eeuw. Amsterdam, Nico Israel, 1976. p.77-102)

942. Vogel, Paul H. "Niederländische und englische Bibeldrucke des 15. und 16. Jahrhunderts." Libri 8, no.2:127-40. 1958.

SWITZERLAND

943. Benziger, Karl J. Geschichte des Buchgewerbes im fürstlichen Benediktinerstifte U.L.V. v. einsiedeln. Einsiedeln, Benziger, 1912. 303p. illus.

944. Bern, Schweizerische Landesbibliothek. Die Bibel in der Schweiz und in der Welt. Bern, 1931. 296p. 22 facs

 Most of the titles come from the Karl J. Lüthi collection in the
 Swiss National Library.

945. Besson, Marius (Bishop). L'église et l'imprimerie dans les anciens diocèses de Lausanne et de Génève jusqu'en 1525. Geneva, 1937-38. 2 vols. illus. plates. facs

946. Henggeler, P. Rudolf. "Die schweizerischer Klosterdruckerein." Sankt Wiborada 6:14-20. 1939.

UNITED STATES

Reference Works

947. Hills, Margaret T., ed. The English Bible in America: a bibli-ography of editions of the Bible and the New Testament published in America 1777-1957. N.Y., American Bible Society, 1961. 477p.

 Contains alphabetic and geographical indexes of publishers and
 printers.

948. O'Callaghan, Edmund B. A list of editions of the Holy Scriptures and parts thereof printed in America previous to 1860. Albany, Munsell and Rowland, 1861. 415p. facs

949. Wright, John. Early Bibles of America; being a descriptive account of Bibles published in the United States, Mexico, and Canada. 3d ed. N.Y., T. Whittaker, 1894. 483p. plates. facs

950. _____. Early prayer books of America; being a descriptive account of prayer books published in the United States, Mexico, and Canada. St. Paul, Privately printed, 1896. 492p. illus. plates. facs

951. _____. Historic Bibles in America. N.Y., Whittaker, 1905. 222p. plates. facs

General Works

952. Adams, Randolph G. "America's first Bibles." Colophon 1:11-20, summer 1935.

953. Durnbaugh, Donald F. "Henry Kurtz; man of the book." Ohio history 76:114-31, summer 1967.

954. Hixson, Richard F. Isaac Collins, a Quaker printer in 18th century America. New Brunswick, Rutgers Univ. Press, 1968. 241p. illus. facs

955. Deleted.

956. Parsons, Wilfrid. Early Catholic Americana; a list of books and other works by Catholic authors in the United States. N.Y., Macmillan, 1939. 282p.

 Contains essay "Early Catholic printers and publishers,"
 p.ix-xxv.

957. Pilkington, James P. The Methodist Publishing House: a history. Vol. 1: Beginnings to 1870. Nashville, Abingdon Press, 1968. 583p. illus.

958. Roberts, W. G. "The Methodist Book Concern in the West 1820-1870." Ph.D. dissertation, Univ. of Chicago, 1947.

959. Schoenberg, Wilfred P. Jesuit mission presses in the Pacific Northwest: a history and bibliography of imprints 1876-1899. Portland, Champoeg Press, 1957. 76p.

960. Simms, Paris M. The Bible in America; versions that have played their part in the making of the Republic. N.Y., Wilson-Erickson, 1936. 394p. facs

961. Tebbel, John. A history of book publishing in the United States. N.Y., Bowker, 1972-81. 4 vols.

 Contains much information on religious printing and publishing.

OTHER COUNTRIES

962. Lenhart, John M. (Rev.). "Capuchins introduce printing into Tibet in 1741." Franciscan studies 10:69-72, Mar. 1950.

963. Satow, Ernest M. The Jesuit mission press in Japan 1591-1610. Privately printed, 1888. 54 leaves. facs

964. Wright, John. "The Bible in Canada." (In Early Bibles of America. 3d ed. N.Y., Whitaker, 1894. p.313-21)

SCIENCE

Reference Works

965. Dibner, Bern. <u>Heralds of science; 200 epochal books and pamphlets</u> <u>selected from the Burndy Library</u>. Norwalk, Conn., Burndy Library, 1955. 96p. facs

966. Duveen, Denis I. <u>Bibliotheca alchemica et chemica; an annotated</u> <u>catalogue of printed books on alchemy, chemistry, and cognate subjects</u> <u>in the library of Denis I. Duveen</u>. 2d ed. London, Dawsons of Pall Mall, 1965. 609p. facs

 Catalogue 62 (1953) from H. P. Kraus supplements Duveen.

967. Horblit, Harrison D. <u>One hundred books famous in science based on</u> <u>an exhibition at the Grolier Club</u>. N.Y., 1964. 449p. illus. facs

968. Hunt, Rachel McMasters. <u>Catalogue of botanical books in the collec-</u> <u>tion of Rachel McMasters Hunt</u>. Pittsburgh, Hunt Botanical Library, 1958-

969. MacPhail, Ian. <u>Alchemy and the occult; a catalogue of books and</u> <u>manuscripts from the collection of Paul and Mary Mellon</u>. New Haven, Yale Univ. Library, 1968- many facs

970. Maggs Bros., London. <u>Manuscripts and books on medicine, alchemy,</u> <u>astrology, and natural sciences</u>. London, 1929. 618p. and index. facs (catalog 520)

971. Osler, William. <u>Bibliotheca Osleriana; a catalogue of books</u> <u>illustrating the history of medicine and science, collected, arranged,</u> <u>and annotated by Sir William Osler and bequeathed to McGill University</u>. Oxford, Clarendon Press, 1929. 785p.

 Reprinted with new prologue, addenda, and corrigenda in 1969.

972. Sallander, Hans. <u>Bibliotheca Walleriana; the books illustrating</u> <u>the history of medicine and science collected by Dr. Eric Waller and</u> <u>bequeathed to the library of the Royal University of Uppsala</u>. Stockholm, Almqvist & Wiksell, 1955. 2 vols. 55 plates.

973. Sotheby Parke Bernet, London. <u>The magnificent botanical library</u> <u>of the Stiftung für Botanik, Vaduz Liechtenstein. Collected by the late</u> <u>Arpad Plesch</u>. London, 1975-76. 3 parts. illus.

974. Sparrow, Ruth A., comp. Milestones of science; epochal books in the history of science as represented in the library of the Buffalo Society of Natural Sciences. Buffalo, Buffalo Museum of Science, 1972. 307p. illus. facs

975. Zetzner, Lazarus. Theatrum chemicum. Argentorati, Sumptibus heredum E. Zetzneri, 1659-61. 6 vols. illus.

History

976. California. University. History of Science Club. Exhibition of first editions of epochal achievements in the history of science ... On display at the University Library. Berkeley, Univ. of California Press, 1934. 48p. illus.

977. Godine, David R. and Gingerich, Owen. Renaissance books of science from the collection of Albert E. Lowndes. Hanover, Dartmouth College, 1970. 123p. illus. plates. (exhibit catalog)

978. Hirsch, Rudolf. "The invention of printing and the diffusion of alchemical knowledge." (In The printed word: its impact and diffusion. London, Variorum Reprints, 1978. Topic 10. 26p.)

979. Klebs, Arnold C. "Gleanings from incunabula of science and medicine." Papers of the Bibliographical Society of America 26:52-88. 1932.

980. Kuh, Hans. "Typography in scientific books." Gebrauchagraphik 29: no.3:44-49. 1958.

981. Sarton, George. A history of science; Hellenistic science and culture in the last three centuries. Cambridge, Harvard Univ. Press, 1959. 554p. facs

982. _____. "The scientific literature transmitted through the incunabula; an analysis and discussion illustrated with 60 facsimiles." Osiris 5:41-245. 1938.

983. _____. "The study of early scientific textbooks." Isis 38:137-48, Feb. 1948.

984. Sotheby Parke Bernet, London. The Honeyman collection of scientific books and manuscripts. London, 1979-80.

985. _____. The library of Harrison D. Horblit, Esq. London, 1974-

 Covers early science, navigation, and travel. Contains facsimiles of many pages.

986. Thornton, John L. and Tully. R. I. J. Scientific books, libraries and collectors. 3d ed. London, Library Association, 1971. 445p. plates.

987. Wilson, Leslie P. The history of the printing of scientific and mathematical texts; an exhibition of books at the Margaret Clapp Library and the Science Center Library of Wellesley College, Sept.-Nov. 1978. Wellesley, Mass., Wellesley College, 1978. 113p. illus.

988. Zeitlin and Ver Brugge, Booksellers. Rare books in the physical sciences. Los Angeles, 1966. 138p. facs

Individual Countries

GERMANY

989. Shipman, Joseph. "Johannes Petreius Nuremberg, publisher of scientific works, 1524-1550." (In Homage to a bookman; essays ... for Hans P. Kraus. Berlin, 1967. p.147-62)

990. Zinner, Ernst. "Verfasser, Buchdrucker und Verleger." (In Geschichte und Bibliographie der astronomischen Literatur in Deutschland zur Zeit der Renaissance. Stuttgart, Hiersemann, 1964. p.55-64)

GREAT BRITAIN

991. Henrey, Blanche. British botanical and horticultural literature before 1800, comprising a history and bibliography of botanical and horticultural books printed in England, Scotland, and Ireland from the earliest times until 1800. London, Oxford Univ. Press, 1975. 3 vols. facs

992. Rostenberg, Leona. Literary, political, scientific, religious and legal publishing, printing, and bookselling in England 1551-1700: twelve studies. N.Y., Burt Franklin, 1965. 2 vols. facs

993. Russell, Kenneth F. British anatomy 1525-1800: a bibliography. Parkville, Melbourne Univ. Press, 1963. 254p. facs

OTHER COUNTRIES

994. Huntington Library and Art Gallery, San Marino, Calif. Science and the new world (1526-1800); an exhibition to illustrate the scientific contribution of the new world and the spread of scientific ideas in America. San Marino, Calif., 1937. 18p. illus.

Written by Theodore Hornberger.

995. Nasr, Seyyed. Islamic science; an illustrated study. London, World of Islam Festival Publishing Co., 1976. 273p. illus. plates (some in color)

HEBREW PRINTING

Reference Works

996. Adler, Elkan N. A gazetteer of Hebrew printing. London, Grafton, 1917. 23p.

997. Brisman, Shimeon. A history and guide to Judaic bibliography. N.Y., Ktav Publishing House, 1977. 352p.

998. Freimann, Aron. Gazetteer of Hebrew printing. N.Y., New York Public Library, 1946. 86p.

999. _____ and Marx, Moses, eds. Thesaurus Typographiae Hebraicae saeculi xv. Berlin, 1924-31. 8 portfolios.

 Contains 332 plates of facsimiles from more than 100 Hebrew incunabula.

1000. Hebrew printing and bibliography. Selected and with a preface by Charles Berlin. N.Y., New York Public Library and Ktav Publishing House, 1976. 518p.

1001. Offenberg, Adri K. "Literature on Hebrew incunabula since the Second World War." (In Hellinga, Festschrift, feestbundel, mélanges. Forty-three studies in bibliography presented to Prof. Dr. Wytze Hellinga. Ed. by A. R. A. Croiset Van Uchelen. Amsterdam, N. Israel, 1980. p.363-77)

1002. Shunami, Shlomo. "Hebrew typography. The Hebrew book." (In Bibliography of Jewish bibliographies. 2d ed. Jerusalem, Magnes Press, The Hebrew Univ., 1965. p.473-534)

 Contains many titles on Hebrew printing in individual countries.

General Works

1003. Adler, Elkan N. "The romance of Hebrew printing." (In About Hebrew manuscripts. London, H. Frowde, 1905. p.116-32)

1004. Duschinsky, Charles. "Books." Universal Jewish encyclopedia 2:458-70. 1940.

1005. Habermann, Abraham M. "The Jewish art of the printed book." (In Roth, Cecil, ed. Jewish art: an illustrated history. N.Y., McGraw-Hill, 1961. p.457-91)

1006. _____. "The Jewish art of the printed book." (In Roth, Cecil, ed. Jewish art: an illustrated history. rev. ed. by Bezalel Narkiss. Greenwich, Conn., N.Y. Graphic Society, 1971. p.163-74)

1007. Howe, Ellic. "An introduction to Hebrew typography." Signature no.5:12-29. 1937.

1008. Jacobs, Joseph. "Typography." Jewish encyclopedia 12:295-335. 1916.

1009. [Jewish physicians active as printers] Harofé haivri 25:204-13. 1952.

1010. Kaniel, Michael. "The art of the Hebrew printed book." (In Judaism. Poole, Dorset, Blandford Press, 1979. p.50-55)

1011. Mehlman, Israel. "What makes antique Hebrew books so rare?" Jewish book annual 39:7-18. 1981/82.

1012. Oppenheimer, Francis J. "Printing--the scribes." (In Ezekiel to Einstein. Israel's gifts to science and invention. N.Y., Liveright, 1940. p.112-17)

1013. Posner, Ralph and Ta-Shema, Israel, eds. The Hebrew book; an historical survey. Jerusalem, Keter Publishing House, 1975. 225p. illus. 16 leaves of plates.

1014. Roth, Cecil. "Printed editions of illustrated Haggadot." Encyclopaedia Judaica 7:columns 1100-1103. 1971.

1015. _____. Studies in books and booklore; essays in Jewish bibliography and allied subjects. Farnborough, England, Gregg International, 1972. 287, 59p. illus.

1016. Sassoon, David S. Catalog of the Sassoon collection of highly important Hebrew printed books. Portion I. London, 1970. 76p. plates. facs

1017. Schonfield, Hugh J. The new Hebrew typography, with an introduction by Stanley Morison and numerous types designed by the author and drawn by Bertram F. Stevenson. London, Denis Archer, 1932. 51p.

1018. Sonne, Isaiah. "Druckwesen." Encyclopedia Judaica 6:39-81. 1930.

1019. Steinschneider, Moritz. "Jüdische Typographie und jüdischer Buchhandel." Allgemeine Encyclopädie der Wissenschaften und Künste. Section 2, pt. 28, p.21-94. 1851.

1020. Yaari, Abraham. Bibliografyah shel Haggadot Pesah. (in Hebrew)
Jerusalem, 1960. 207, xx, xip. facs

Bibliography of editions to 1960 with 25 reproductions from rare
editions. Addenda in Studies in Jewish bibliography, history,
and literature in honor of Dr. I. Edward Kiev (N.Y., 1971)

1021. Zilberberg, Gershon. "Hebrew printing." Encyclopedia Judaica
13:columns 1096-1116. 1971.

History

1022. Beit-Arie, M. "The affinity between early Hebrew printing and
manuscripts." (In Essays and studies in librarianship presented to
Curt David Wormann on his seventy-fifth birthday. Jerusalem, Magnes
Press, Hebrew Univ., 1975. Hebrew part, p. 27-39)

1023. Castellani, G. "Girolamo Soncino." Bibliofilia 9:22-31. 1907/08.

1024. Clair, Colin. "Early Jewish printing." (In A history of European
printing. London, Academic Press, 1976. p.204-06)

1025. Frankel, David, Bookseller. Hebräische Inkunabeln 1475-1494.
Vienna, 1931. 13, 3p. facs

1026. Freimann, Aron. "Über hebräische Inkunabeln." (In Wilhelm,
Kurt. Wissenschaft des Judentums im deutschen Sprachgebiet. Tübingen,
1967. vol. 2, p.571-77)

1027. Glaister, Geoffrey. "Hebrew printing before 1600." (In Glaister's
Glossary of the book. 2d ed. Berkeley, Univ. of California Press, 1979.
p.224-26)

1028. Lowy, Jacob M. Hebrew incunabula (post-incunabula) and early
Hebrew printers. Montreal? 1965? 24p. facs

1029. Manzoni, Giacomo. Annali tipografici dei Soncini. Bologna,
1883-86.

Issued in fascicles. Each part has a separate title page.

1030. Marx, Alexander. "Some notes on the use of Hebrew type in non-
Hebrew books 1475-1520." (In Bibliographical essays; a tribute to
Wilberforce Eames. Cambridge, Printed at Harvard Univ. Press, 1924.
p.380-408)

1031. Mezer, Hermann M. "Incunabula." Encyclopedia Judaica 8:columns
1319-44. 1971.

1032. Sacchi, Federico. I tipografi ebrei di Soncino. Cremona, Ronzi,
1877. 71p. illus.

1033. Simonsen, David J. Hebraisk bogtryk i aeldre og nyere tid.
Copenhagen, 1901. 29p. illus.

1034. Thomas, Alan G. "Early books in Hebrew." (In Great books and book collectors. N.Y., Putnam, 1975. p.112-25)

Individual Countries

FRANCE

1035. Ginsburger, Moses. "Les premiers imprimeurs juifs en France." Revue des études juives 86:47-57. 1928.

1036. Gruss, Noë. "L'imprimerie hebräique en France (xvie-xixe siècle)." Revue des études juives 125:77-91. 1966.

GERMANY

1037. Carmoly, Eliakim. "De la typographie hebräique à Metz." Revue orientale 3:209-15, 282-89. 1843/44.

1038. Monumenta Judaica. 2000 Jahre Geschichte und Kultur der Juden am Rhein. Cologne, Kölnische Stadtmuseum, 1964. 2 vols. plates. maps. (exhibit catalog)

1039. Weinberg, Magnus. Die hebräischen Druckerein in Sulzbach (1669-1851). Frankfurt, A. I. Hofman, 1904. 186p.

ITALY

1040. Amram, David W. The makers of Hebrew books in Italy. Phila., J. H. Greenstone, 1909. 417p. illus.

1041. Bloch, Joshua. "Hebrew printing in Naples." Bulletin of the New York Public Library 46:489-514, June 1942.

1042. _____. "Venetian printers of Hebrew books." Bulletin of the New York Public Library 36:71-92, Feb. 1932.

1043. Carmoly, Eliakim. Annalen der hebräischen Typographie von Riva di Trento (1558-1562). 2d ed. Frankfurt, Hess, 1868. 16p.

1044. Freimann, Aron. Die hebräischen Drucke in Rom im 16. Jahrhundert. (In Festschrift Dr. Jakob Freimann. 1937. p.53-67)

1045. Sonnino, Guido. Storia della tipografia ebraica in Livorno. Turin, 1912. 104p.

NETHERLANDS

1046. Bloom, Herbert I. "The printing and book trade." (In The economic activities of the Jews of Amsterdam in the seventeenth and eighteenth centuries. Williamsport, Pa., Bayard Press, 1937. p.44-60)

1047. Offenberg, Adri K. "The first use of Hebrew in a book printed in the Netherlands." Quaerendo 4:44-54. 1974.

1048. Zafren, Herbert C. "Amsterdam: center of Hebrew printing in the seventeenth century." Jewish book annual 35:47-55. 1977/78.

PORTUGAL

1049. Amzalak, Moses B. A tipografia hebraica em Portugal no seculo xv. Coimbra, 1922. 44p. plates.

1050. Bloch, Joshua. Early Hebrew printing in Spain and Portugal. N.Y., New York Public Library, 1938. 54p. illus. facs

> Reprint from the New York Public Library bulletin, May 1938, p.371-420.

1051. Deleted.

SPAIN

1052. Bloch, Joshua. Early Hebrew printing in Spain and Portugal. N.Y., New York Public Library, 1938. 54p. illus. facs

1053. Sonne, Isaiah. "The beginnings of Hebrew printing in Spain." Kirjath Sepher 14:368-74. 1937/38.

UNITED STATES

1054. Eames, Wilberforce. On the use of Hebrew types in English America before 1735. N.Y., 1929. 22p. facs

> Reprint from Studies in Jewish bibliography and related subjects in memory of Abraham S. Freidus. N.Y., 1929. p.481-502.

1055. Rosenbach, Abraham S. W. An American Jewish bibliography being a list of books and pamphlets by Jews or relating to them printed in the United States from the establishment of the press in the colonies until 1850. American Jewish Historical Society, 1926. 486p. facs

OTHER COUNTRIES

1056. Dan, Robert. "The first Hebrew printed text in Vienna." Studies in bibliography and booklore 9:101-05. 1970.

1057. Davies, Raymond A. Printed Jewish Canadiana, 1685-1900. Montreal, L. Davies, 1955. 56p. illus. facs

1058. Friedberg, Bernhard. Histoire de la typographie hébräique des villes suivantes en Europe centrale: Altona, Augsburg, Berlin, Cologne, [and other cities] Antwerp. 1935. 128p.

 Includes 19 cities.

1059. _____. History of Hebrew typography in Italy, Spain, Portugal, Turkey, and the Orient ... Biographies of the first printers, their assistants and successors. (Translation of the Hebrew title) Antwerp, 1934. 140p. 48 facs

1060. Roth, Cecil. "The origins of Hebrew typography in England." Journal of Jewish bibliography 1, no.1:2-9, Oct. 1938.

PRIVATE PRESSES

Reference Works

1061. Anderson, Frank J. Private press work; a bibliographic approach to printing as an avocation. N.Y., A. S. Barnes, 1977. 168p.

1062. Cave, Roderick. "Bibliography." (In The private press. London, Faber and Faber, 1971. p. 347-63)

1063. Encyclopedia of library and information science. N.Y., Marcel Dekker, 1968-82. 33 vols.

1064. Haas, Irvin. A bibliography of material relating to private presses. Chicago, Black Cat Press, 1937. 57p.

1065. _____. "A periodical bibliography of private presses." Bulletin of bibliography 15:46-50. 1934.

1066. Private Libraries Association. Private press books 1959- Pinner, Middlesex, 1960- Annual.

1067. Rae, Thomas and Handley-Taylor, Geoffrey. The book of the private press; a checklist. Greenock, Signet Press, 1958. 48p.

> A directory of more than 240 amateur printers in the English-speaking world.

1068. Ryder, John. "The contemporary private press." (In Glaister, Geoffrey. An encyclopedia of the book. Cleveland, World, 1960. Appendix C, p.465-69).

Printers' Manuals

1069. Allen, Lewis. Printing with the handpress. Herewith a definitive manual ... to encourage fine printing through hand-craftsmanship. N.Y., Van Nostrand Reinhold, 1969. 75p.

1070. Francis, Jabez. Printing at home. Rochford, Essex, The Author, n.d. 52, 8 leaves.

1071. Jahn, Hugo. Hand composition. N.Y., Wiley, 1931. 341p. illus. facs

1072. Raynor, P. E. Printing for amateurs. London, 1876.

1073. Ryder, John. *Printing for pleasure.* rev. ed. London, The Bodley Head, 1976. 129, 14p. illus.

General Works

1074. Archer, H. Richard. "The private press: its essence and recrudescence." (In *Modern fine printing; papers read at the Clark Library seminar, March 11, 1967.* By H. Richard Archer and Ward Ritchie. Los Angeles, Clark Memorial Library, Univ. of California, 1968. p.3-15)

1075. _____. "Private presses and collector's editions." *Library trends* 7:57-65, July 1958.

1076. Cave, Roderick. *The private press.* London, Faber and Faber, 1971. 376p. illus. 72 plates.

Contains an excellent bibliography, p.347-63.

1077. _____. "Private press typefaces." (In *The private press.* London, Faber and Faber, 1971. p.303-45)

1078. _____. "Private presses." *Encyclopedia of library and information science* 24:193-205. 1978.

1079. Cole, William A. *The influence of fine printing.* Pittsburgh, Dept. of Printing, Carnegie Institute of Technology, 1929. 41p.

1080. Grannis, Chandler B., ed. *Heritage of the graphic arts; a selection of lectures delivered at Gallery 303, New York City under the direction of Dr. Robert L. Leslie.* N.Y., Bowker, 1972. 291p. illus.

Contains articles on typographers and printers, including Bruce Rogers, Rudolf Koch, Will Ransom, Victor Hammer, and Lucien Bernhard.

1081. Great Britain. British Council. *Private presses and their background; catalogue for an exhibition of books and associated material.* London, 195-? 56p.

Part I is on backgrounds and influences. The catalogue was compiled by Percival H. Muir.

1082. Morris, Henry. *Omnibus: instructions for amateur papermakers with notes on private presses, book printing and some people who are involved in these activities.* North Hills, Pa., Bird and Bull Press, 1967. 121p. illus.

1083. Mosley, James. "The press in the parlour: some notes on the amateur and his equipment." *Black art* 2:2-16, spring 1963.

1084. Pollard, Alfred W. "Private presses and their influence on the art of printing." *Ars typographica* 1:36-42, autumn 1934.

1085. "The task of the private press; marginal books and improving
standards." Times literary supplement, Apr. 26, 1963, p.294.

1086. Thomas, Alan G. "Private press books." (In Great books and book
collectors. N.Y., Putnam, 1975. p.214-33)

1087. _____ . "Private presses." (In Fine books. N.Y., Putnam,
1967. p.103-19)

History

1088. Cave, Roderick. The private press. London, Faber and Faber,
1971. 376p. illus. 72 plates.

1089. Grannis, Ruth S. "Modern fine printing." (In Wroth, Lawrence C.
A history of the printed book. N.Y., Limited Editions Club, 1938.
p.269-93)

1090. Lackmann, Adam H. Annalium typographique.... Hamburg, 1970.
167p.

 Chapt. 8 contains information on early private presses.

1091. McLean, Ruari. Modern book design, from William Morris to the
present day. London, Faber and Faber, 1958. 115p. illus. plates.
facs

1092. McMurtrie, Douglas C. "Contemporary fine printing." (In
The book. 3d ed. London, Oxford Univ. Press, 1943. p.484-99)

1093. _____ . "The private presses." (In The book. 3d ed. London,
Oxford Univ. Press, 1943. p.462-83)

1094. Symons, A. J. A. "An unacknowledged movement in fine printing;
the typography of the eighteen-nineties." Fleuron no.7:83-119. 1930.

PRINTERS' MARKS

Reference Works

1095. Ris-Paquot, Oscar E. <u>Dictionnaire encyclopédique des marques et monogrammes, chiffres, lettres initiales, signes figuratifs....</u> Paris, H. Laurens, 1893. 2 vols.

1096. Roth-Scholtz, Friedrich. <u>Thesaurus symbolicum ac embelematum; i.e., signia bibliopolorum et typographorum ab incunabulis typographiae ad nostra visque tempora.</u> Nuremberg, 1730. 64p. plates.

1097. Sharpe, John L. III. "An index to printers' marks in the <u>Library quarterly.</u>" <u>Library quarterly</u> 48:40-59, Jan. 1978.

General Works

1098. Bauer, Konrad F. <u>Der Greif; eine Geschichte des Buchdrucker-Wappentieres.</u> Frankfurt, Bauersche Giesserei, 1938. 60p. illus.

1099. Bayley, Harold. <u>A new light on the Renaissance displayed in contemporary emblems.</u> London, Dent, 1909. 270p. illus.

1100. Davies, Hugh W. <u>Devices of the early printers 1457-1560; their history and development.</u> London, Grafton, 1935. 707p. illus.

1101. Delalain, Paul A. <u>Inventaire des marques d'imprimeurs et de libraires de la collection du Cercle de la Librairie.</u> 2d ed. Paris, Cercle de la Librairie, 1892. 355p.

1102. Donati, Lamberto. <u>Raflessioni sulle marche tipografiche.</u> Bellinzona, S. A. Grassi, 1959. 7-33p.

1103. Dwiggins, William A. <u>22 printers' marks and seals designed or redrawn by W. A. Dwiggins.</u> N.Y., William E. Rudge, 1929. 26 leaves.

1104. Gruel, Léon. <u>Recherches sur les origines des marques anciennes qui se rencontrent dans l'art et dans l'industrie du xva au xixx siècle.</u> Paris, Van Oest, 1926. 110p.

1105. Hornung, Clarence P. "Printer's marks 1457-1941." <u>Print</u> 2, nos. 3 and 4:49-63, Oct./Dec. 1941.

1106. Horodisch, Abraham. The book and the printing press in printer's marks of the fifteenth and sixteenth centuries. Amsterdam, Erasmus, 1977. 79p. (Safaho monographs, vol. 7)

1107. Irwin, Frank. Printers' marks and colophons. Tilton, N. H., Hillside Press, 1976. 51[4]p. illus.

1108. Johnson, Henry L. Historic design in printing. Reproductions of book covers, borders, initials, decorations, printers' marks and devices. Boston, Graphic Arts Co., 1925. 193p. plates.

1109. Juchhoff, Rudolf. Drucker- und Verlegerzeichen des xv Jahrhunderts in den Niederlanden, England, Spanien, Böhmen, Mähren, und Polen. Munich, Verlag der Münchner Drucke, 1927. 131p.

1110. Klikar, František. Knizni signet. V Preze, 1959. 149p. illus.

1111. Landauer, Bella C. Printer's mottoes. N.Y., 1926. 122p. plates.

1112. Livingston, Mark, ed. "A panoply of printers' marks 1975 to 1980." Fine print 5:102-09, Apr. 1979.

 Printers' marks of private presses in the U. S., England, and Germany.

1113. McMurtrie, Douglas C. "Printers' marks." (In The book; the story of printing and bookmaking. 3d ed. London, Oxford Univ. Press, 1943. p.289-303)

1114. _____. Printers' marks and their significance. Chicago, Eyncourt Press, 1930. 7-29p. illus.

1115. Moran, James. Heraldic influence on early printer's devices. Leeds, Elmete Press, 1978. 104p.

1116. New York Public Library. Cuts, borders, and ornaments. Selected from the Robinson-Pforzheimer typographical collection in the New York Public Library. N.Y., 1962. 44 leaves of illus.

1117. Reiner, Imre. Das Buch der Werkzeichen. St. Gallen, Zollikofer, 1945. 122p.

1118. Roberts, William. Printers' marks; a chapter in the history of typography. London, G. Bell, 1893. 261p. illus.

1119. Schechter, Frank I. "Early printers' and publishers' devices." Papers of the Bibliographical Society of America 19:1-28. 1925.

1120. Sjögren, Arthur. Om boktryckare- och forläggaremarken under 1400-talet. Stockholm, 1908. 65p. illus.

1121. Thibaudeau, François. La lettre d'imprimerie; origine, developpement, classification. Paris, 1921. 2 vols. illus. plates.

1122. Victoria and Albert Museum, London. Early printers' marks. London, HMSO, 1962. unpaged. illus.

1123. Volkmann, Ludwig. Bilderschriften der Renaissance; Hieroglyphik und Emblematik in ihren Beziehungen und Fortwirkungen. Leipzig, Hiersemann, 1923. 132p. illus.

1124. Willoughby, Edwin E. Fifty printers' marks. Berkeley, Book Arts Club, Univ. of California, 1947. 153p.

Individual Countries

FRANCE

1125. Baudrier, Henri L. Bibliographie lyonnaise. Lyon, A. Brun, 1895-1921. 12 vols in 11. illus. facs

1126. Horodisch, Abraham. "Buch und Buchdruckpresse im Druckersignet des 15. und 16. Jahrhunderts." Philobiblon 18:166-94. 1974.

1127. Laurent-Vibert, Robert and Audin, Marius. Les marques de libraires et d'imprimeurs en France au xxviie et xviiie siècles. Paris, Champion, 1925. 250 numbered leaves.

1128. Meyer, Wilhelm J. Die französischen Drucker- und Verlegerzeichen des xv Jahrhunderts. Munich, Verlag der Münchner Drucke, 1926. 171p.

1129. Polain, Louis. Marques des imprimeurs et libraires en France au xve siècle. Paris, Droz, 1926. 207p. illus.

1130. Renouard, Philippe. Les marques typographiques parisiennes des xve et xvie siècle. Paris, Champion, 1926-28. 381p.

1131. Silvestre, Louis C. Marques typographiques en France ... 1470 jusqu'à la fin du xvie siècle. Paris, 1867. 2 vols. facs

GERMANY

1132. Berjeau, Jean P. Early Dutch, German, and English printers' marks. London, E. Rascol, 1866-69. Issued in parts. 100 facs

1133. Grimm, Heinrich. Deutsche Buchdruckersignete des xvi. Jahrhunderts; Geschichte, Sinngehalt und Gestaltung kleiner Kulturdokuments. Wiesbaden, Guido Pressler, 1965. 365p. 144 printer's marks.

1134. Heichen, Paul H. Die Drucker- und Verleger- Zeichen der Gegenwart. Berlin, 1892. 36p. 28 plates.

1135. Heitz, Paul. Frankfurter und Mainzer Drucker- und Verlegerzeichen bis in das 17. Jahrhundert. Strassburg, Heitz, 1896. xvp. 84 plates.

1136. _____ . Die Kölner Büchermarken bis Anfang des xvii Jahrhunderts. Strassburg, Heitz, 1898. 5p. plates.

1137. Johnson, Alfred F. "Devices of German printers." Library 20:81-107, June 1965.

1138. Meiner, Annemarie. Das deutsche Signet. Leipzig, 1922. 71p. illus.

1139. Weil, Ernst. Die deutschen Druckerzeichen des xv Jahrhunderts. Munich, Verlag der Münchner Drucke, 1924. 105p. illus.

GREAT BRITAIN

1140. Avis, Frederick C. English printers' marks of the fifteenth century. London, G. Bell, 1963. 24p. facs

1141. _____. English printers' marks of the sixteenth century. London, G. Bell, 1965. 64p. facs

1142. Balsamo, Luigi. "I primordi della tipografia in Italia e Inghilterra." Bibliofilia 79, no.3:231-62. 1977.

1143. Berjeau, Jean P. Early Dutch, German, and English printers' marks. London, E. Rascol, 1866-69. Issued in parts. 100 facs

1144. Davies, Hugh W. Devices of the early printers 1457-1560; their history and development. London, Grafton, 1935. 707p. illus. facs

 Reprinted by William Dawsons and Sons in 1974.

1145. Duff, Edward G. et al. Handlists of books printed by London printers, 1501-1556. London, Printed by Blades, East and Blades for the Bibliographical Society, 1913. various pagination. illus.

 Contains printers' marks.

1146. McKerrow, Ronald B. Printers' and publishers' devices in England and Scotland 1485-1640. London, Bibliographical Society, 1913. 216p. facs

 See W. Craig Ferguson, "Some additions to McKerrow's Printers and publishers' devices." Library 13:201-03. 1958. See also J. A. Lavin, "Additions to McKerrow's devices." Library 23:191-205, Sept. 1968.

1147. Roberts, William. "The printer's mark in England." (In Printers' marks. London, G. Bell, 1893. p.52-99)

1148. Ryder, John. Flowers and flourishes. Including a newly annotated edition of "A suite of fleurons." London, Bodley Head for MacKays, 1976. 168p. illus.

1149. _____. A suite of fleurons, or a preliminary enquiry into the history and combinable natures of certain printers' flowers. London, Phoenix House, 1956. 54p. illus.

ITALY

1150. Ascarelli, Fernanda. La tipografia cinquecentina italiana.
Florence, Sansoni, 1953. 259p.

1151. Balsamo, Luigi. I primordi della tipografia in Italia e
Inghilterra. Bibliofilia 79, no.3:231-62. 1977.

1152. Husung, Maximilian J. Die Drucker- und Verlegerzeichen Italiens
im xv. Jahrhunderts. Munich, Verlag der Münchner Drucke, 1929. 172p.

1153. Kristeller, Paul. Die italienischen Buchdrucker- und Verleger-
zeichen bis 1525. Strassburg, J. H. Heitz, 1893. 143p. illus.

NETHERLANDS

1154. Berjeau, Jean P. Early Dutch, German, and English printers' marks.
London, E. Rascol, 1866-69. Issued in parts. 100 facs

1155. Bradshaw, Henry. List of the founts of type and woodcut devices
used by printers in Holland in the fifteenth century. London, Macmillan,
1871. 23p.

1156. Ledeboer, Adrianus M. Alphabetische lijst der boekdrukkers, boek-
verkopers en uitgevers in Noord-Nederland sedert de uitvinding van de
boekdrukkunst tot den aavvang der 19e eeuw. Utrecht, 1876. 198p. facs
Chronological register, 1877. 80p.

1157. Nielsen, A. C. "Latinjnse zinspreuken op drukkersmerken."
Talenblad, 11. jaarg, no.9:23-245, Feb. 1950; 11 jaarg, no.10:271-78,
Mar. 1950.

1158. Nijhoff, Wouter. L'art typographique dans les Pays-Bas pendant
les années 1500 à 1540. The Hague, M. Nijhoff, 1926. 2 vols.

1159. Oyen, Anthonie A. Vosterman van. Les dessinateurs néerlandais
d'exlibris. Arnhem, 1910. 40, 10p.

1160. _____. Les marques d'imprimeurs. Arnhem, 1910. 12p.

1161. Peeters-Fontaines, Jean. Bibliographie des impressions espagnoles
des Pays-Bas. Louvain, 1933. 245p. facs

1162. _____. Bibliographie des impressions espagnoles des Pays-Bas
méridionaux. Mise au point avec la collaboration de Anne-Marie Frédéric.
Nieuwkoop, B. de Graaf, 1965. 2 vols. facs

 Printers' marks in vol. 2, p.729-809.

1163. Rahir, Edouard. Catalogue d'une collection unique de volumes
imprimés par les Elzevier et divers typographes hollandais du xvii$^{\mathbf{e}}$
siècles. Paris, Morgand, 1896. 491p. illus.

1164. Schretlen, Martin J. "Drukkersmerken in Hollandsche Inkunabeln."
Halcyon no.5:3-11. 1941.

1165. _____. "Printers' devices in Dutch incunabula." Ars typo-
graphica 3:53-64, July 1926.

SWITZERLAND

1166. Heitz, Paul. Basler Büchermarken bis zum Anfang des 17. Jahr-
hunderts. Strassburg, Heitz, 1895. 111p. illus.

1167. _____. Genfer Buchdrucker- und Verlegerzeichen im xv, xvi,
und xvii Jahrhundert. Strassburg, Heitz, 1908. 56p. 168 illus.

1168. _____. Die zürcher Büchermarken bis zum Anfang des 17. Jahr-
hunderts. Zurich, Fasi and Beer, 1895. 47p. illus.

UNITED STATES

1169. Hamilton, Sinclair. "The earliest device of the colonies' and
some other early devices." Princeton University Library chronicle
10:117-23, Apr. 1949.

1170. Hornung, Clarence P. "Printers' marks." Printing news 1938 to
1940.

A series of 80 articles on the marks of contemporary American
printers.

1171. Weygand, James L. A collection of press marks gathered from
American private presses and from others not so private. Nappanee,
Indiana, James L. Weygand, 1956. 94p. illus.

1172. _____. A second book of pressmarks gathered from America's
private presses and others not so private. Nappanee, Indiana, Private
Press of the Indiana Kid, 1959. 102p. illus.

1173. _____. A third book of pressmarks gathered from America's
private presses and others not so private. Nappanee, Indiana, Private
Press of the Indiana Kid, 1959. 102p. illus.

OTHER COUNTRIES

1174. Bibliotheca Belgica. Bibliographie générale des Pays-Bas.
Fondée par Ferdinand van der Haegen. 2d ed. Réedités sous la direction
de Marie-Thérèse Langer. Brussels, Culture et Civilisation, 1964-75.
7 vols.

1175. Binyon, Laurence and Sexton, J. J. Japanese colour prints. Ed.
by Basil Gray. 2d ed. Boston, Boston Book and Art Shop, 1960. 230p.
illus. 48 plates.

1176. Bowes, James L. Japanese marks and seals. London, Henry
Sotheran, 1882. 379p. illus.

> Part II is on illuminated manuscripts and printed books. The
> volume was reprinted by Ars Ceramica in Ann Arbor, Mich. in 1976.

1177. Ghent. University. Bibliotheca belgica. Marques typographiques
des imprimeurs. Ghent, 1894. 2 vols.

⁻.78. Haebler, Konrad. Spanische und portugiersche Bücherzeichen des
:.v. und xvi. Jahrhunderts. Strassburg, Heitz, 1898. 46p.

1179. Lam, Stanislaw. Polskie znaki ksiegarskie. Warsaw, Laskauera,
1921. 29p.

1180. Nohrström, Holger. Boktryckamärchen i Finland. Helsingfors,
1925. 84p.

1181. Roth, Cecil. "Printers' marks." Encyclopedia Judaica 13:columns
1095-96. 1971.

1182. Végh, Gyula. Ofner Buchhändlermarchen 1488-1525. Budapest, 1923.
27p. illus.

1183. Vindel, Angulo Francisco. Escudos y marcas de impresores y
libreros en España durante los siglos xv a xix (1485-1850)....
Barcelona, Editorial Orbis, 1942. 636p. 818 facs. Appendix, 1950. 50p.

1184. Yaari, Abraham. Digle hamadpisim ha'ivriyim. Jerusalem, 1943.
194p. 208 illus.

> Contains facsimiles of printers' marks from the beginning of
> Hebrew printing to the end of the 19th century. The reprint in
> 1971 by Gregg International has 8 more marks. See supplement
> in Kirjath sepher 31:501-06. 1955/56. The supplement contains
> an English text.

————14————
FORGERY AND FICTITIOUS IMPRINTS

Reference Works

1185. Brunet, Gustave. Imprimeurs imaginaires et libraires supposés....
Paris, Tross, 1866. 290p.

1186. Parenti, Marino. Dizionario dei luoghi di stampa falsi, inventati
o supposti in opere di autori et traduttori italiani.... Florence,
Sansoni, 1951. 311p. facs

1187. Weller, Emil. Die fälschen und fingierten Druckorte.... Leipzig,
Engelmann, 1864. 2 vols.

> Vol. 1: German and Latin writings; vol. 2: French writings.
> Reprinted in 3 vols in 1960-61 by Hildesheim.

General Works

1188. Baughman, Roland. "Some Victorian forged rarities." Huntington
Library bulletin 9:91-117, Apr. 1936.

> About the Wise forgeries.

1189. Brunet, Gustave. Fantaisies bibliographiques. Paris, J. Gay,
1864. 312p.

1190. _____. Recherches sur les imprimeries imaginaires clandestines
et particulières. Brussels, Gay et Douce, 1879. 113p.

> Reprinted in 1967 by B. R. Grüner in Amsterdam.

1191. Bühler, Curt F. "False information in the colophons of incuna-
bula." Procs of the American Philosophical Society 114:398-406. 1970.

1192. Carter, John and Pollard, Graham. Enquiry into the nature of cer-
tain nineteenth century pamphlets. London, Constable, 1934. 400p.
4 plates.

> The authors have demonstrated that 30 pamphlets by Thomas J. Wise
> contain internal evidence of the falsity of their imprints. See
> reviews and discussion in Library 15:379-84, Dec. 1934; Book
> collector's quarterly 15:1-16, July/Sept. 1934; and Saturday
> review of literature 11:45-46, Aug. 11, 1934.

1193. Dickinson, Asa D. "Frauds, forgeries, fakes and facsimiles." Library journal 60:135-41, Feb. 1935.

1194. Farrer, James A. Literary forgeries. London, Longmans, Green, 1907. 282p.

1195. Heartman, Charles F. "Fakes, forgeries, and frauds." American book collector 2:261-69, Nov. 1932.

1196. Katz, W. A. "Machinery of detection." American book collector 16:23-30, Oct. 1969.

1197. Partington, Wilfred. Forging ahead; the true story of the upward progress of Thomas James Wise. N.Y., Putnam, 1939. 315p. illus.

1198. Todd, William B., ed. Thomas J. Wise, centenary studies. Austin, Univ. of Texas Press, 1959. 128p.

1199. Whitehead, John. This solemn mockery; the art of literary forgery. London, Arlington Books, 1973. 177p. illus.

CLASSIFIED CHECKLIST OF SELECTED TITLES ON WRITING AND CALLIGRAPHY

"The significance of the relationship between scripts and printing types is that printing has preserved Renaissance letter-forms and has a standard of legibility from which it is well that contemporary penmen should not stray too far." --Alfred Fairbank in A Book of Scripts (rev. ed., 1968)

"The fifteenth century book was avowedly an imitation of a fine manuscript; its type was a copy of the current writing hand, the arrangement of its page was that of a manuscript, its spacing or justification were facilitated by the free use of contractions." Robert Steele in The Revival of Printing (1912)

Cobden-Sanderson said that when printing was young "the printer carried into type the tradition of the calligrapher and the calligrapher at his best. As this tradition died out in the distance, the craft of the printer declined. It is the function of the calligrapher to revive and restore the craft of the printer to its original purity of intention and accomplishment." --Quoted in Paul Standard's Calligraphy's Flowering, Decay and Restauration (1947)

Bibliographies

Bianco y Sanchez, Rufino. Catalogo de caligrafos y grabadores de letra con notas bibliograficas de sus obras. Madrid, 1920. 80p.

Bonacini, Claudio. Bibliografia della arti scrittorie e della calligrafia. Florence, Sansoni, 1953. 409p.

Braswell, Laurel N. Western manuscripts from classical antiquity to the Renaissance: a handbook. N.Y., Garland, 1981. 382p.

British Columbia. University. Asian Studies Division. A bibliography on the history of the Chinese book and calligraphy. Victoria, 1970. 19 leaves.

Cohen, Marcel. La grande invention de l'écriture et son évolution. vol. 2: Documentation et index. Paris, Impr. Nationale, 1958. 226p.

Davis, Jinnie Y. and Richardson, John V. Calligraphy, a sourcebook. Littleton, Colo., Libraries Unlimited, 1982. 222p.

Diringer, David. The alphabet; a key to the history of mankind. 3d ed.
Completely revised with the assistance of Reinhold Regensburger. N.Y.,
Funk and Wagnalls, 1968. 2 vols. (many bibliographies following
topics in the text)

Doede, Werner. Bibliographie deutscher Schreibmeisterbücher von Neudörf-
fer bis 1800. Hamburg, Hauswedell, 1958. 123p.

Heal, Ambrose. The English writing masters and their copybooks 1570-1900;
a biographical dictionary and a bibliography. Cambridge, Univ. Press,
1931. 225p.

Herrick, Virgil E. Handwriting and related factors 1890-1960. Wash.,
D.C., Handwriting Foundation, 1960. 134p.

London. University Library. The paleography collection in the Univer-
sity of London Library; an author and subject catalog. Boston, G. K.
Hall, 1968. 2 vols.

Marzoli, Carla C. Calligraphy, 1535-1885; a collection of seventy-two
writing books and specimens from the Italian, French, Low Countries
and Spanish schools, catalogued and described. Milan, La Bibliofila,
1962. 175p.

Mateu Ibars, Josefina and Dolores. Bibliografia paleografica. Barcelona,
Universidad de Barcelona, Facultad de Filosofia y Letras, Departamento
de Paleografia y Diplomatica, 1974. 932p.

Nash, Ray. American penmanship 1800-1850; a history of writing and a
bibliography of copybooks from Jenkins to Spencer. Worcester, American
Antiquarian Society, 1969. 303p.

_____. American writing masters and copybooks; history and bibli-
ography through colonial times. Boston, Colonial Society of Massachu-
setts, 1959. 77p.

Sattler, Paul and Selle, Götz von. Bibliographie zur Geschichte der
Schrift bis in das Jahr 1930. Archiv für Bibliographie. Beiheft
17. 1935. 234p.

Glossary

Hyde, Robert C. A dictionary for calligraphers. Los Angeles, Martin
Press, 1977. unpaged.

Biographical Reference Works

Bradley, John W. A dictionary of miniaturists, illuminators, callig-
raphers, and copyists, with references to their works and notices of
their patrons from the establishment of Christianity to the eighteenth
century. London, B. Quaritch, 1887-89. 3 vols.

Campos Perreira Lima, Henrique de. Subsidios para um dicionario bio-
bibliografico dos caligrafos portugueses. Lisbon, Oficinas Graficas
de Biblioteca Nacional, 1923. 76p.

Cotarelo y Mori, Emilio. Diccionario biografico y bibliografico de
caligrafos españoles. Madrid, 1913-16. 2 vols.

Heal, Ambrose. The English writing masters and their copybooks 1570-
1800; a biographical dictionary and a bibliography. Cambridge, Univ.
Press, 1931. 225p.

Hsüan-ho shu P'U. Shanghai, Commercial Press, 1936. 2 vols.

Kim, Yong-yun. Biographical dictionary of Korean artists and callig-
raphers. 1959. 566p. (in Korean)

Kondo, Gensui, ed. Kokun shina shoga meika shoden. Tokyo, 1918.
13 vols.

Rico Y Sinobas, Manuel. Diccionario de caligrafos españoles; con un
apendice sobre los caligrafos mas recientes. Madrid, 1903. 272p.

Shodo jiten. 1975. 971p.

Writing Manuals

Augustino da Siena, the 1568 edition of his writing book in facsimile.
With an introduction by Alfred Fairbank. London, Merrion Press, 1975.
unpaged.

Benson, John H. and Carey, Arthur G. The elements of lettering. Newport,
Rhode Island, J. Stevens, 1940. 125p.

Bickham, George. The universal penman, engraved by George Bickham.
Facsimile edition. N.Y., Dover, 1941. 6p., 212 numbered leaves.

Chiang, Yee. Chinese calligraphy; an introduction to its aesthetic and
technique. 3d ed. rev. and enl. Cambridge, Harvard Univ. Press,
1973. 250p.

Cresci, Giovanni F. Essemplare di piu sorti lettere. Ed., with an
introduction and translation, by A. S. Osley. London, Nattali and
Maurice, 1968. 51, 32p.

Fairbank, Alfred J. A handwriting manual. rev. and enl. London, Faber
and Faber, 1975. 144p.

Goudy, Frederic W. The alphabet and elements of lettering. rev. and
enl. Berkeley, Univ. of California Press, 1942, 101p.

Hewitt, Graily. Lettering for students and craftsmen. London, Seeley,
Service, 1930. 336p.

Iciar, Juan de. A facsimile of the 1550 edition of Arte subtilissima. With a translation by Evelyn Shuckburgh and an introduction by Reynolds Stone. London, Lion and Unicorn Press, 1958. 171p.

Johnston, Edward. Writing and illuminating, and lettering. rev. ed. London, Pitman, 1939. 434p.

Eager, Fred. Guide to italic handwriting. rev. ed. Caledonia, N.Y., Italimuse, 1967. 80p. (new rev. ed., 1974, has title: The italic way to beautiful handwriting, cursive and calligraphic.)

Greenspan, Jay Seth. Hebrew calligraphy; a step-by-step guide. N.Y., Schocken, 1981. 166p.

Käch, Walter. Rhythm and proportion in lettering. Tr. from the German by Elizabeth Friedlander. Olten, Walter, 1956. 81p.

Mitchell, T. F. Writing arabic; a practical introduction to Ruq'ah script. London, Oxford Univ. Press, 1953. 163p.

Osley, A. S. Scribes and sources; handbook of the chancery hand in the sixteenth century. Texts from the writing masters selected, introduced, and translated by A. S. Osley. With an account of John de Beauchesne by Berthold Wolpe. London, Faber and Faber, 1980. 291p.

Pierre le Bé, Bele Priérie, Paris 1601. Ed. by Jan Tschichold. Stuttgart, Bad Constatt, Dr Cantz'schen Druckerei, 1976. unpaged.

Podwal, Mark. A book of Hebrew letters. Phila., Jewish Publication Society of America, 1978. 64p.

Reiner, Imre and Reiner, Hedwig. Lettering in book art. St. Gall, Zollikofer, 1948. 95p.

Reynolds, Lloyd. Italic calligraphy and handwriting. Exercises and text. N.Y., Pentalic Corp., 1969. 62p.

Schwandner, Johann G. Calligraphy; Calligraphia Latina. N.Y., Dover, 1958. (originally published in 1756)

Shepherd, Margaret. Capitals for calligraphy. N.Y., Collier Books, Macmillan, 1981. 118p.

_____. Learning calligraphy; a book of lettering, design, and history. N.Y., Collier Books, Macmillan, 1978. 121p.

_____. Using calligraphy; a workbook of alphabets, projects, and techniques. N.Y., Collier Books, Macmillan, 1979. 143p.

Siebert, Kurt. Meisterbuch deutsche Schrift. Berlin, 1934. 15p.

Standard, Paul. Arrighi's running hand; a study of chancery cursive including a facsimile of the 1522 Operina with side by side translation and an explanatory supplement to help beginners in the italic hand. N.Y., Taplinger, 1979. 67p.

Three classics of Italian calligraphy; an unabridged issue of the writing books of Arrighi, Tagliente, and Palatino. Introduction by Oscar Ogg. N.Y., Dover, 1953. 272p.

Tory, Geoffroy. Champ fleury. Tr. into English and annotated by George B. Ives. N.Y., Grolier Club, 1927. 208p.

Verini, Giovanni B. Luminario; or the third chapter of the Liber elementorum litterarum on the construction of roman capitals. In an English version by A. F. Johnson, with an introduction by Stanley Morison. Cambridge, Harvard College Library, 1947. 31p.

Zapf, Hermann. Pen and graver; alphabets and pages of calligraphy. N.Y., Museum Books, 1952. 25 leaves. (Translation of Feder und Stichel)

Facsimiles

Degering, Hermann. Lettering; modes of writing in western Europe from antiquity to the end of the eighteenth century. N.Y., Universe Books, 1965. 240p.

_____. Die Schrift. Atlas der Schriftformen des Abendlandes vom Altertum bis zum Ausgang des 18. Jahrhunderts. 3d ed. Tübingen, Wasmuth, 1952. 240p.

Fairbank, Alfred J. A book of scripts. Harmondsworth, Penguin Books, 1949. 36p. rev. ed., 1968.

Hoffmanns Schriftatlas. Ed. by Alfred Finsterer. Stuttgart, Julius Hoffmann, 1952. 210p.

New Paleographical Society, London. Facsimiles of ancient manuscripts 1st-2d series. London, 1903-1930. 4 vols.

Paleographical Society, London. Facsimiles of manuscripts and inscriptions. 1st-2d series. London, 1873-1894. 5 vols. Indexes, 1901. 63p.

Silvestre, Joseph B. Paléographie universelle. Paris, Firmin Didot frères, 1841. 4 vols.

Tschichold, Jan. Geschichte der Schrift in Bildern. 2d ed. Basel, Holbein-Verlag, 1946. 18p. 70 plates.

Whalley, Joyce I. The pen's excellencie; calligraphy of western Europe and America. Tunbridge Wells, Kent, Midas Books, 1980. 400p.

_____. The universal penman; a survey of western calligraphy from the Roman period to 1980; catalogue of an exhibition at the Victoria and Albert Museum, London, July-Sept. 1980. London, HMSO, 1980. 152p.

History of Writing and Calligraphy

Anderson, Donald M. The art of written forms; the theory and practice
of calligraphy. N.Y., Holt, Rinehart, and Winston, 1969. 358p.

Baker, Arthur. Arthur Baker's historic calligraphic alphabets. N.Y.,
Dover, 1980. 89p.

Blunt, Wilfrid. Sweet Roman hand; five hundred years of italic cursive
script. London, J. Barrie, 1952. 99p.

Child, Heather. Calligraphy today. rev. ed. London, Studio Vista,
1976. 112p.

Cohen, Marcel S. La grande invention de l'écriture et son évolution.
Paris, Imprimerie Nationale, 1958. 2 vols. and portfolio of 95 plates.

Day, Lewis F. Penmanship of the sixteenth, seventeenth, and eighteenth
centuries. N.Y., Scribner's, 1911. 12p. 112 facs on 100 plates.

Diringer, David. The alphabet; a key to the history of mankind. 3d ed.
completely revised with the assistance of Reinhold Regensburger. N.Y.,
Funk and Wagnalls, 1968. 2 vols.

_____. Writing. N.Y., Praeger, 1965. 261p.

Drogin, Marc. Medieval calligraphy; its history and technique.
Montclair, N.J., Allanheld and Schram, 1980. 198p.

Fairbank, Alfred J. The story of handwriting; origins and development.
N.Y., Watson-Guptill, 1970. 108p.

_____ and Wolpe, Berthold. Renaissance handwriting; an anthology of
italic scripts. London, Faber and Faber, 1960. 104p.

Février, James. Histoire de l'écriture. Paris, Payot, 1948. 607p.

Gelb, Ignace J. Study of writing. rev. ed. Chicago, Univ. of Chicago
Press, 1963. 319p.

Holme, Rathbone and Frost, Kathleen M. Modern lettering and calligraphy.
London, Studio, 1954. 144p.

Istrin, Viktor A. Razvitiye pisma. Moscow, 1961. 394p.

Jackson, Donald. The story of writing. N.Y., Taplinger, The Parker Pen
Co., 1981. 176p.

Morison, Stanley. Selected essays on the history of letter-forms in
manuscript and print. Ed. by David McKitterick. Cambridge, Univ.
Press, 1981. 2 vols.

Muzika, František. Die schöne Schrift in der Entwicklung des lateinischen
Alphabets. Prague, Artia, 1965. 2 vols.

Tannenbaum, Samuel A. The handwriting of the Renaissance. N.Y., Columbia Univ. Press, 1930. 210p.

Ullman, Berthold. Ancient writing and its influence. N.Y., Longmans, Green, 1932. 234p.

_____. The origin and development of humanistic script. Rome, 1960. 146p.

Wardrop, James. The script of humanism; some aspects of humanistic script 1460-1560. Oxford, Clarendon Press, 1963. 57p.

Wattenbach, Wilhelm. Das Schriftwesen im Mittelalter. 3d ed. Leipzig, Hirzel, 1896. 670p.

Paleography and Diplomatic

Bischoff, Bernhard. Paläographie des römischen Altertums und des abendländischen Mittelalters. Grundlagen der Germanistik 24. Berlin, E. Schmidt, 1979. 361p.

Boüard, Alain de. Manuel de diplomatique française et pontificale. Paris, A. Picard, 1929-52. 2 vols. and 3 portfolios of plates.

Cencetti, Giorgio. Lineamenti di storia della scrittura latina. Bologna, R. Patron, 1956. 522p.

_____. Paleografia latina. Rome, Jouvence, 1978. 195p.

Costanza, Salvatore. Sommario di paleografia latina e greca, nozioni di diplomatica. Messina, Peloritana, 1970. 185p.

Falconi, Ettore. L'edizione diplomatica del documento e del manoscritto. Parma, La Nazionale, 1969. 173p.

Foerster, Hans P. Abriss der lateinischen Paläographie. 2d rev. ed. Stuttgart, Hiersemann, 1963. 322p.

Gardthausen, Viktor. Griechische Paläographie. Leipzig, Veit, 1911-13. 2 vols.

Giry, Arthur. Manuel de diplomatique. new ed. Paris, F. Alcan, 1925. 944p.

Groningen, Bernard A. van. Short manual of Greek paleography. 3d ed. Leyden, Sythoff, 1963. 66p.

Hector, Leonard C. Paleography and forgery. London, St. Anthony's Press, 1959. 18p.

Jakó, Sigismund and Manolescu, Radu. Scierea latină in evul mediu. Bucharest, Editura Stiintifica, 1971. 184p. Album, 1971. 40p. 50 leaves of facs

Kirchner, Joachim. Scriptura gothica libraria. Monachii, R. Oldenbourg, 1955. 54p.

Prou, Maurice. Manuel de paléographie latine et française. 4th ed. Refondue avec la collaboration de Alain de Boüard ... accompagnée d'un album de 24 planches. Paris, A. Picard, 1924. 511p.

Schubart, Wilhelm. Das Buch bei den Griechen und Römern. 3d ed. Hrsg. von Eberhard Paul. Leipzig, Koehler und Amelang, 1961. 157p.

Stiennon, Jacques. Paléographie de moyen age. Paris, Colin, 1973. 352p.

Thompson, Edward M. An introduction to Greek and Latin paleography. Oxford, Clarendon Press, 1912. 600p.

Turner, Eric G. Greek manuscripts of the ancient world. Princeton, Princeton Univ. Press, 1971. 132p.

Semitic Writing

Reference Works

Fazali, Habib Allah. Atlas i khatt. 1971. 695p.

Vajda, Georges. Album de paléographie arabe. Paris, Adrien-Maisonneuve, 1958. 3 leaves. 77 facs

Zayn-al-din, Naji. Atlas of Arabic calligraphy. 2d ed. Baghdad, Iraq Academy, 1972. 423p.

General Works

Arnold, Thomas W. and Grohmann, Adolf. The Islamic book; a contribution to its art and history. Paris, Pegasus Press, 1929. 131p.

Aziza, Mohamed. La calligraphie arabe. Tunis, S.T.D., 1973. 141p.

Driver, Godfrey R. Semitic writing. Ed. by S. A. Hopkins. new rev. ed. Oxford, Univ. Press, 1976. 276p.

Grohmann, Adolf. Arabische Paläographie. Vienna, 1967-71. 2 vols.

Khatibi, Abdelkeber and Sijelmassi, Mohammed. The splendour of Islamic calligraphy. London, Thames and Hudson, 1976. 254p. (a translation by James Hughes of L'art calligraphique arabe)

Kühnel, Ernst. Islamische Schriftkunst. Berlin, Heintze & Blanckertz, 1942. 86p. 2d ed., 1972.

Naveh, Joseph. The development of the Aramaic script. Jerusalem, Israel Academy of Science and Humanities, 1970. 69p.

Peckham, John B. The development of the late Phoenician scripts.
Cambridge, Harvard Univ. Press, 1968. 233p.

Safadi, Yasin H. Islamic calligraphy. Boulder, Shambhala, 1979. 144p.

Welch, Anthony. Calligraphy in the arts of the Muslim world. Published
in cooperation with the Asia Society, N.Y., Univ. of Texas Press,
Austin, 1979. 216p.

HEBREW

Birnbaum, Solomon A. The Hebrew scripts. London, Paleographica, 1954-57.
2 vols.

Blau, Ludwig. Studien zum althebräischen Buchwesen und zur biblischen
Literaturgeschichte. Strassburg, Trubner, 1902. 203p.

Gesenius, Friedrich H. Geschichte der hebräischen Sprache und Schrift.
Leipzig, Vogel, 1815. 231p.

Sed-Rajna, Gabrielle. Manuscrits hébreux de Lisbonne. Paris, 1970.
113p.

Bible Script

Cross, Frank M., Jr. The ancient library of Qumrân and modern Biblical
studies. London, Duckworth, 1958. 196p. rev. ed., 1961.

Hamburg. Deutsches Bibel-Archiv. Schrift, Bild und Druck der Bibel.
1255. 1455. 1955. Hamburg, 1955. 92p. (exhibit catalog)

Hatch, William Henry. Facsimiles and descriptions of minuscule manu-
scripts of the New Testament. Cambridge, Harvard Univ. Press, 1951.
289p.

Kenyon, Frederic G. Our Bible and the ancient manuscripts. 4th ed.
London, Eyre & Spottiswoode, 1939. 266p.

Merrill, George E. The story of the manuscripts [of the New Testament]
Boston, D. Lothrop, 1881. 201p.

Rabin, Chaim and Yadin, Y., eds. Aspects of the Dead Sea Scrolls.
Jerusalem, Magnes Press, 1958. 282p.

Numerals

Reference Work

Pouget, Jean H. Dictionnaire des chiffres et des lettres ornées.
Paris, Tillard, 1767. 5, 60, cxivp. 207, 34 plates

General Works

Friedlein, Gottfried. Die Zahlzeichen und des elementare Rechnen der Griechen und Römer. Erlangen, Deichert, 1869. 164p.

Griffith, C. L. T. The story of letters and numbers. London, Kegan, Paul, 1939. 199p.

Irwin, Keith G. The romance of writing: from Egyptian hieroglyphics to modern letters, numbers and signs. N.Y., Viking, 1956. 160p.

Menninger, Karl W. Number words and number symbols; a cultural history of numbers. Tr. by Paul Broneer from the rev. German edition. Cambridge, M.I.T., 1969. 480p.

_____. Zahlwort und Ziffer; eine Kulturgeschichte der Zahl. 2d ed. Göttingen, Vanderhoeck & Ruprecht, 1957-58. 2 vols.

Shaw, Henry. Alphabets, numerals, and devices of the middle ages. London, W. Pickering, 1845. 4p. and 47 plates.

Smith, David E. and Karpinski, Louis C. The Hindu-Arabic numerals. Boston, Ginn, 1911. 160p.

Willers, Friedrich A. Zahlzeichen und Rechnen im Wandel der Zeit. Berlin, Volk und Wissen, 1949. 82p.

CLASSIFIED CHECKLIST OF SELECTED TITLES ON TYPOGRAPHY

"The tendency of the best typography has been and still should be in the path of simplicity, legibility, and orderly arrangement."--Theodore L. De Vinne

"The typographer's true task is to bring to each book the grace, distinction, and convenience proper to its content; and to make the title and every other part mutually reflect each other."--Paul Standard in the preface to Hermann Zapf's Typographic Variations (1964)

Reference Works

Avis, Frederick C. Typeface terminology. Privately printed, 1965. 52p.

Chautard, Emile. Glossaire typographique.... Paris, Editions Denoël, 1937. 155p.

Gesellschaft für Typenkunde des xv Jahrhunderts. Veröffentlichen. Leipzig, 1907-1943. plates 1-2460.

Haebler, Konrad. Typenrepertorium der Wiegendrucke. Halle a.s. and c., 1905-24. 6 parts in 5 vols.

Jaspert, W. Pincus et al. Encyclopedia of type faces. 4th ed. London, Blandford Press, 1970. 420p.

Southward, John. A dictionary of typography and its accessory arts. 2d ed. London, Powell, 1875. 138p.

Williamson, Hugh A. Book typography: a handlist for book designers. London, Published for the National Book League by the Cambridge University Press, 1955. 15p.

General Works

Dair, Carl. Design with type. 2d ed. Toronto, Univ. of Toronto Press, 1967. 162p.

Fournier, Pierre Simon. Manuel typographique. Paris, 1764-66. 2 vols.

Gill, Eric. An essay on typography. 2d ed. London, Sheed and Ward, 1936. 133p.

Gray, Bill. Tips on type. N.Y., Van Nostrand Reinhold, 1983. 128p.

Knuttel, Gerard. The letter as a work of art; observations and con-frontations with contemporaneous expressions of art from Roman times to the present day. Amsterdam, 1951. 263p.

Morison, Stanley. First principles of typography. N.Y., Macmillan, 1936.

_____. Letter forms, typographical and scriptorial; two essays on their classification, history, and bibliography. London, Nattali and Maurice, 1968. 167p.

Thibaudeau, François. La lettre d'imprimerie; origine, développement, classification, and 12 notices illustrées sur les arts du livre. Paris, Bureau de l'Edition, 1921. 2 vols.

Tschichold, Jan. Ausgewälte Aufsätze über Fragen der Gestalt des Buches und der Typographie. Basel, Birkhäuser, 1975. 214p.

Warde, Beatrice. The crystal goblet; sixteen essays on typography. Selected and edited by Henry Jacob. Cleveland, World, 1956. 221p.

Type Design and Lettering

Bastien, Alfred. Alphabet in type; a survey of typographic letter-design. West Drayton, Middlesex, England, A. J. Bastien, 1958. 301p.

Goudy, Frederic W. The elements of lettering. N.Y., Kennerley, 1922. 48p.

_____. Typologia; studies in type design and type making.... Berkeley, Univ. of California Press, 1940. 170p.

Harvey, Michael. Lettering design: form and skill in the design and use of letters. London, Bodley Head, 1975. 159p.

Krimpen, Jan van. On designing and devising type. N.Y., The Typofiles, 1957. 107p.

Lindegren, Erik, ed. ABC of lettering and printing types. N.Y., Museum Books, 1964-66. 3 vols.

Middleton, Robert H. Creating type. N.Y., Diamant Typographic Service, 1949. 75p.

Renner, Paul F. Mechanisierte Grafik; Schrift, Typo, Film, Farbe. Berlin, Reckendorf, 1930. 205p.

Ruzicka, Rudolph. Studies in type design. Hanover, N.H., Friends of the Dartmouth Library, 1968. portfolio (4p. and 10 colored plates)

Scarfe, Laurence. Alphabets; an introductory treatise on written and printed letter forms for the use of students. London, Batsford, 1954. 191p.

Tory, Geoffroy. L'art et science de la vraye proportion des lettres, alliques ou antiques.... Paris, 1549. (2d ed. of Champfleury)

Tschichold, Jan. Die neue Typographie. Berlin, 1928. 240p.

_____. Meisterbuch der Schrift. Ravensburg, Maier, 1952. 238p.

Zapf, Hermann. About alphabets; some marginal notes on type design. Cambridge, MIT Press, 1970. 142p.

Typefaces

British Standards Institution. Typeface nomenclature and classification (2961). London, 1967. 12p.

Dowding, Geoffrey. Factors in the choice of type faces. London, Wace, 1957. 131p.

Carter, Harry and Vervliet, Hendrik D. L. Civilités types. Oxford, Univ. Press, 1966. 138p.

Hutchings, Reginald. A manual of script typefaces. N.Y., Hastings House, 1965. 92p.

Morison, Stanley. Black-letter text. Cambridge, Univ. Press, 1942. 38p.

Initial Letters

Grafton, Carol B., ed. Historic alphabets and initials woodcut and ornamental. N.Y., Dover, 1977. 175p.

Jennings, Oscar. Early woodcut initials, containing over 1300 reproductions of ornamental letters of the fifteenth and sixteenth centuries. London, Methuen, 1908. 287p.

Johnson, Alfred F. Decorative initial letters. London, Cresset Press, 1931. 247p.

Nesbitt, Alexander. Decorative alphabets and initials. N.Y., Dover, 1959. 192p.

Type Specimen Books

Reference Works

Annenberg, Maurice. Type foundries of America and their catalogs (1806-1941). Baltimore, Maran Printing Services, 1975. 245p.

Berry, William T. and Johnson, Alfred F. Catalogue of specimens of
printing types by English and Scottish founders, 1665-1830. London,
Oxford Univ. Press, 1935. 98p.

Audin, Marius. Les livrets typographiques des fonderies françaises
avant 1800; étude historique et bibliographique. Avec un supplément
par M. Ellic Howe. Amsterdam, Van Heusden, 1934. 210p.

Specimen Books

American Typefounders Co. Specimen book and catalog.... Jersey City,
1923. 1148p.

Antwerp. Musée Plantin-Moretus. Index characterum archetypographiae
plantinianae.... Spécimen des caractères employés dans l'Imprimerie
plantinienne. Antwerp, 1905. 90p.

Austin Letter Foundry, London. Specimen books of types cast. London,
1839.

Biegeleisen, Jacob I. Handbook of typefaces and lettering for artists,
typographers, letterers, teachers, and students. 4th ed. N.Y., Arco,
1982. 264p.

Binny and Ronaldson, Phila. The specimen books of Binny and Ronaldson,
1809-1812, in facsimile. With an introduction by Carl Purington
Rollins and some early American types. Connecticut, The Columbiad
Club. New Haven, Yale Univ. Press, 1936. various pagination.

Blake and Stephenson, London. Specimen of printing types. Sheffield,
1832.

Boston Type Foundry. Specimens from the Boston Type Foundry. Boston,
1883.

Cambridge University Press. Cambridge University Press printing types
and ornaments. 3d ed. Cambridge, 1909. 184 numbered leaves, 23p.

Caslon, Henry, firm, London. Specimen of printing types. London, 1842.
1 vol. unpaged.

Caslon and Livermore, London. Specimen of printing types. London,
Bensley, 1832. 196 leaves.

Clowes, William and Sons, London. Book types. 2d ed. London, 1950.
622p.

Curwen Press, London. A specimen book of types and ornaments in use at
the Curwen Press. London, The Fleuron, 1928.

De Vinne Press, N.Y. Types of the De Vinne Press.... N.Y., 1907. 449p.

Enschedé, firm, printers, Haarlem. A selection of types from six cen-
turies in use at the office of Joh. Enschedé en Zonen at Haarlem.
Haarlem, 1930. 110p.

Figgins, Vincent. Vincent Figgins type specimens, 1801 and 1815, repro-
duced in facsimile. Ed. with an introduction and notes by Berthold
Wolpe. London, Printing Historical Society, 1967. unpaged.

Fournier, Pierre Simon. Fournier on typefounding; the text of the Manuel
typographique (1764-1766) translated into English and edited with notes
by Harry Carter. London, Soncino Press, 1930. 314p.

Graphic Arts Typographers, N.Y. Graphic arts typebook ... machine compo-
sition. N.Y., Reinyold, 1965. 2 vols.

Imprimerie Nationale, Paris. Album typographique de l'Imprimerie Royale.
Paris, Impr. Royale, 1830. 32 leaves.

Hlavsa, Oldrich et al. A book of type and design. Tr. by Silvia Fink
in cooperation with Kim Taylor. London, Tudor, 1961. 494p. (Trans-
lation of Typografická písma latinková)

Johnson, L. and Co. Book of specimens of plain and fancy printing types,
borders, cuts, rules, etc. Phila., 1865. 582 numbered leaves.

King, Jean C. and Esposito, Tony. The designer's guide to text type.
N.Y., Van Nostrand Reinhold, 1980. 319p.

Klinkhardt, Julius. Gesamt-Probe der Schriftgiesserei Julius Klinkhardt
in Leipzig und Wien. Leipzig, 1885. (578) p.

Kynoch Press, Birmingham. Specimen of types in use at the Kynoch Press.
Birmingham, 1934. 160p.

Lieberman, J. Ben. Types of typefaces and how to recognize them. N.Y.,
Sterling, 1967. 132p. 2d ed. published by Myriade, New Rochelle,
N.Y., under the title of Type and typefaces (1978).

MacKay (W. and J.) and Co. Type for books; a designer's manual.
new ed. London, Bodley Head, 1976. 280p.

Morison, Stanley. A tally of types cut for machine composition and
introduced at the University Press, Cambridge, 1922-1932. Cambridge,
1953. 101p.

Norwood Press, Norwood, Massachusetts. Specimen book of linotype faces.
Norwood, 1940? 137p.

Pelican Press, London. Typography.... London, 1923. 20 numbered leaves.
12 leaves of illus. (Compiled and for the most part written by Francis
Meynell)

Pelouze, Lewis and Son, Phila. Specimens of printing types, ornaments,
borders, rules, etc. Phila., 1856. 143 leaves.

Riverside Press, Cambridge. Specimen book of types and ornaments of the
Riverside Press. Cambridge, Mass., 1870. 96p. 97-100 numbered leaves.
101-12p.

Stempel, (D.) A. G., Frankfurt. Die Kunst im Buchdruck; Originalschnitte der Schriftgiesserei D. Stempel. Frankfurt, 1914. 64p.

Sutton, James and Bartram, Alan. An atlas of type forms. N.Y., Hastings House, 1968.

Zapf, Hermann. Manuale typographicum. Frankfurt, G. K. Schauer, 1954.

Type Ornamentation

Alberti, E. G., ed. Nineteenth century initials, ornaments, and borders. London, Coptic Press, 1965-66. 4 vols. of illus.

Gray, Nicolete. Nineteenth century ornamented types and title-pages. London, Faber and Faber, 1938. 213p. new ed., 1976.

Hutchings, Reginald S. A manual of decorated typefaces. N.Y., Hastings House, 1965. 96p.

Lehner, Ernest. Alphabets and ornaments. N.Y., Dover, 1952. 256p.

N.Y. Public Library. Cuts, borders, and ornaments. Selected from the Robinson-Pforzheimer typographical collection in the New York Public Library. N.Y., 1962. 44 leaves of illus.

Pictorial archive of printer's ornaments from the Renaissance to the twentieth century. Selected by Carol Belanger Grafton. N.Y., Dover, 1980. 121p.

Portugal. Imprensa Nacional de Lisboa. Vinhetas e ornatos tipograficos. Lisbon, Imprensa Nacional, 1971. 63p.

Ryder, John. Flowers and flourishes; a demonstration of ornament on the printed page. Lordswood, Chatham, England, W. & J. Mackay, 1972. 74p.

_____. Flowers and flourishes. Including a newly annotated edition of "A suite of fleurons." London, Bodley Head for MacKays, 1976. 168p.

Shearn, Alan L. Fleurons; an historical approach with illustrations and notes concerning their use. Thames Ditton (Surrey), Ember Press, 1971. 38p.

Title Page

Bammes, Reinhold. Der Titelsatz, seine Entwicklung und seine Grundsätze. Leipzig, Deutscher Buchgewerbes, 1911. 99p.

De Vinne, Theodore L. The practice of typography: a treatise on title pages, with numerous illustrations in facsimile and some observation on the early and recent printing of books. N.Y., Century, 1902. 485p.

Gray, Nicolete. Nineteenth century ornamented types and title pages. London, Faber and Faber, 1938. 213p. new ed., 1976.

Johnson, Alfred F. One hundred title-pages 1500-1800, selected and arranged with an introduction and notes. N.Y., Appleton, 1928. 100 plates.

Morison, Stanley. The art of the printer; 250 title and text pages selected from books composed in the roman letter printed from 1500 to 1900. London, Benn, 1925. 7p. 245 facs

Nesbitt, Alexander. 200 decorative title pages. N.Y., Dover, 1964. unpaged.

Pollard, Alfred M. Last words on the history of the title page, with notes on some colophons.... London, Nimmo, 1891. 39p.

Colophons

Irwin, Frank. Printers' marks and colophons. Tilton, N. H., Hillside Press, 1976. 55p.

Kennard, Joseph S. Some early printers and their colophons. Phila., Jacobs, 1902. 129p.

Pollard, Alfred W. An essay on colophons with specimens and translations. Chicago, Caxton Club, 1905. 198p.

Spencer, Geoffrey. Some observations on the colophon. Vancouver, Alcuin Society, 1972. 20 leaves.

Legibility

Burt, Cyril. A psyclological study of typography. Cambridge, Univ. Press, 1959. 67p.

Mergenthaler Linotype Co. The readability of type. Brooklyn, 1947. 67p.

Pyke, Richard L. Report on the legibility of print. London, HSMO, 1926. 123p.

Richaudeau, François. La lisibilité. new ed. Paris, Retz-C.E.P.L., 1976. 301p.

Ryder, John. The case for legibility. London, Bodley Head, 1979. 77p.

Shaw, Alison. Print for partial sight. London, Library Association, 1969. 92p.

Spencer, Herbert. _The visible word_. 2d ed. London, Lund Humphries in association with the Royal College of Art, 1969. 107p. (Published also by Hastings House in New York)

Tinker, Miles A. _Legibility of print_. Ames, Iowa State Univ. Press, 1963. 329p.

Zachrisson, Bror. _Studies in the legibility of printed text_. Stockholm, Almqvist & Wiksell, 1965. 225p.

History of Typography

Audin, Marius. _Histoire de l'imprimerie par image. vol. 2: la lettre_. Paris, H. Jonquières, 1929. 105p.

Carter, Harry G. _A view of early typography up to about 1600_. Oxford, Clarendon Press, 1969. 137p.

Day, Kenneth, ed. _Book typography 1815-1965 in Europe and the United States of America_. Chicago, Univ. of Chicago Press, 1965. 401p.

Denman, Frank. _The shaping of our alphabet; a study of changing type styles_. N.Y., Knopf, 1955. 228p.

Dowding, Geoffrey. _An introduction to the history of printing types_. London, Wace, 1961. 277p.

Goudy, Frederic W. _A half century of type design and typography, 1895-1945_. N.Y., The Typofiles, 1946. 2 vols.

Grannis, Chandler B., ed. _Heritage of the graphic arts_. N.Y., Bowker, 1972. 291p.

Hutchings, Reginald S. _The western heritage of type design_. London, Gory, Adams and MacKay, 1963. 127p.

Johnson, Alfred F. _Type designs, their history and development_. London, Grafton, 1934. 232p.

Johnston, Paul. _Biblio-Typographica; a survey of contemporary fine printing style_. N.Y., Covici, Friede, 1930. 303p.

Morison, Stanley. _Selected essays on the history of letter-forms in manuscript and print_. Ed. by David McKitterick. Cambridge, Univ. Press, 1981. 2 vols.

_____ and Day, Kenneth. _The typographic book 1450-1935; a study of fine typography through five centuries exhibited in upwards of three hundred and fifty title and text pages drawn from presses working in the European tradition_. Chicago, Univ. of Chicago Press, 1963. 98p.

Simon, Oliver et al. _Printing of today; an illustrated survey of post-war typography in Europe and the United States_. N.Y., Harper, 1928. 159p.

Spencer, Herbert. Pioneers of modern typography. N.Y., Hastings House, 1970. 159p. 2d ed., 1982.

Thibaudeau, Francis. La lettre d'imprimerie; origine, développement, classification, et 12 notices illustrés sur les arts du livre. Paris, 1921. 2 vols.

Typomundus 20. N.Y., Reinhold, 1966. unpaged.

Updike, Daniel B. Printing types: their history, forms, and use. 3d ed. Cambridge, Belknap Press, 1962. 2 vols.

Vitu, Auguste C. Histoire de la typographie. Paris, Delagrave, 1886. 169p. 2d ed., 1892.

AUTHOR INDEX

The numbers in this index refer to entry numbers, not page numbers.

SUBJECT INDEX

The numbers in this index refer to entry numbers, not to page numbers.

Xylography see Block books

Young, Robert, 892

Zurich: printers' marks to the
 17th century, 1168